A Wolf's Guide to Art History

Written and Illustrated By:
Brian R. Parks &
Kelli Delach

Copyright 2010 By Brian R. Parks and Kelli Delach

Illustrations By Brian R. Parks and Kelli Delach 2012.
All Rights Reserved.

ISBN-13: 978-1475210545

DEDICATIONS:

I would like to extend my most sincere thank you to my family and friends, for believing in this project, and supporting me through its creation. A special thank you to Jim and Maura Sweeney for giving this book a guiding light to help set the story in the right direction and allow us to flesh it out. Finally, I'd like to thank my co-author and co-illustrator Kelli for embarking on this crazy dream with me and helping to make it into a reality.

—Brian R. Parks

I would like to dedicate this to young artists wanting to learn and grow. As my professor William Otremsky would say to inspire artists: "Work hard". Many thanks to him and my other teachers that molded me as well as to my friends (this means you, Ruth Ellingson) and parents that supported me, even if that support came in the form of constructive criticism. Never underestimate the value of that! Thanks also to Brian. The creative process can be an arduous thing, thank you for making me see this through.

—Kelli Delach

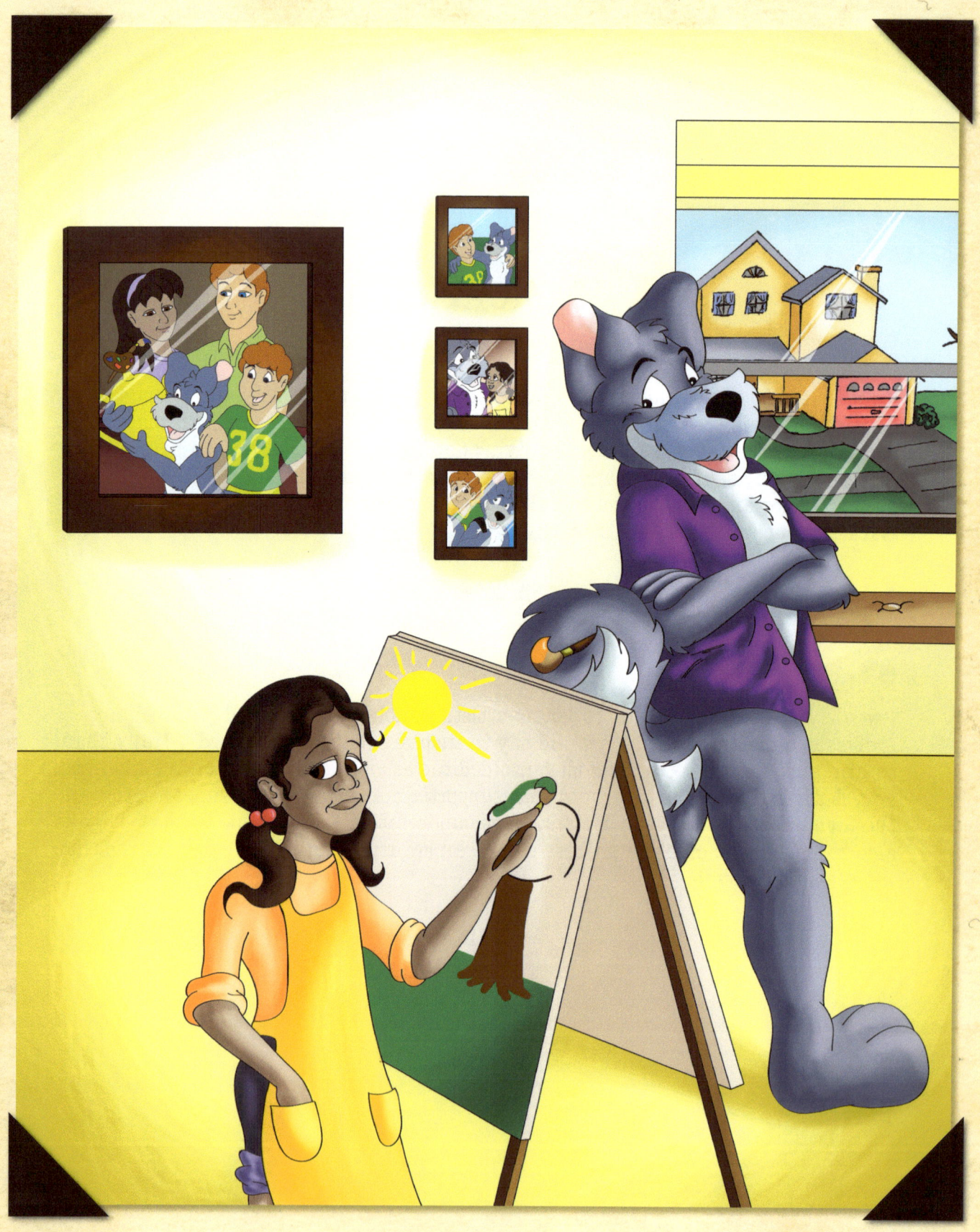

CHAPTER 1

Paint splattered and smeared across a set of canvases as Fenny and his niece were putting the finishing touches on their latest creations. Fenny loved spending time with his niece, and Kat was just as happy to spend time with her favorite fuzzy uncle.

You see Fenny is a wolf, a rather special wolf. In fact, Fenny is much like anyone else. He has a family with a mom and a dad, and an older brother, that, when he was little, liked to pick on him. He has his interests, oh yes... his interests... these make him a very unusual wolf indeed. His love of drawing and painting, and more than all else, his love of learning helped him become the illustrator he is today.

Most afternoons Fenny would pick his niece up from the bus stop and bring her back to his home studio, until her mom and dad came to pick her up after work. Of course, Fenny was always working on some new project, and usually he had a special project or fun activity ready for her to do with him, and today was no exception as they painted away. However, there was something that seemed to be bothering her.

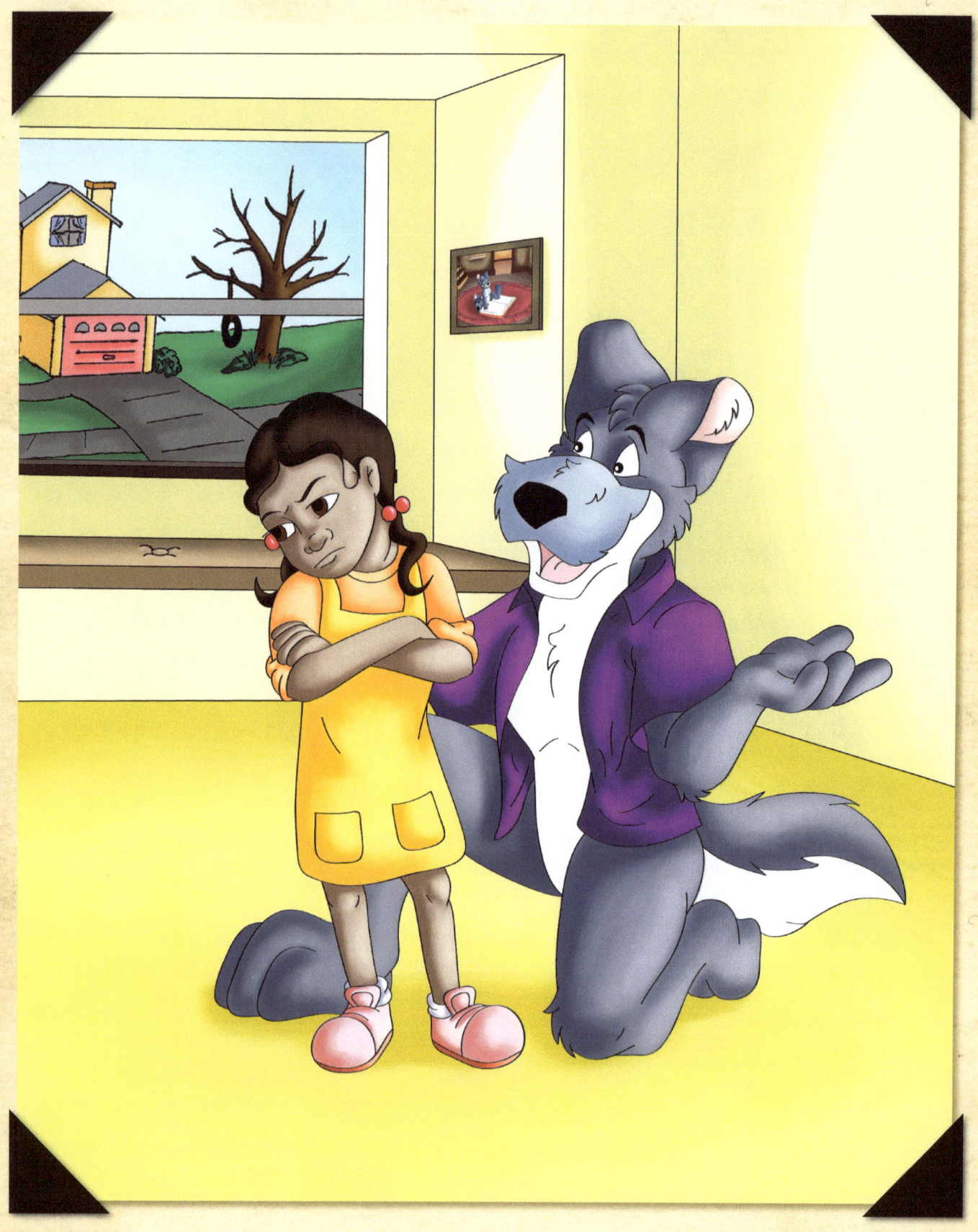

"Kat, is something wrong?" Fenny asked as he swished his tail curiously. "I thought you liked to paint with me?"

"I do uncle Fenny, but, well..." His ears flicked and his tail swayed from side to side patiently. "My art teacher in school was telling us about these new lessons she's going to start. I know you say it's important for an artist to learn as much as they can, but it sounds so boring. And, I just don't understand what it has to do with art." She groaned.

"Oh, it can't be that bad. What kinds of lessons are they?" He asked.

"History." She groaned. Fenny's eyes lit up and his ears snapped forward.

"Boring?!" He laughed. "How can you say such a thing about something as wonderful as art history?" He asked with an amused glint in his eyes. "In fact when I was your age, they couldn't keep me out of the museum."

"But, it's just a bunch of names and dates and boring junk like that." She said losing hope that her uncle would understand her situation. He was starting to sound less like her fun-loving uncle, and more like a grown-up.

"Yes, but there's also other artists, and styles, and great masterpieces throughout history that you need to know, especially if you really want to be an artist when you grow up too." He explained as he sat down with her and pulled out an old book. She leaned over curiously. "In fact, when I was just a little pup, I always loved looking through the big books of art we had around the house." Fenny explained as he pointed out a picture of himself on the wall. "Art has played some pretty big roles throughout history, which is one of the reasons I'm so fond of it." He smiled brightly as he flipped through the pages of the book.

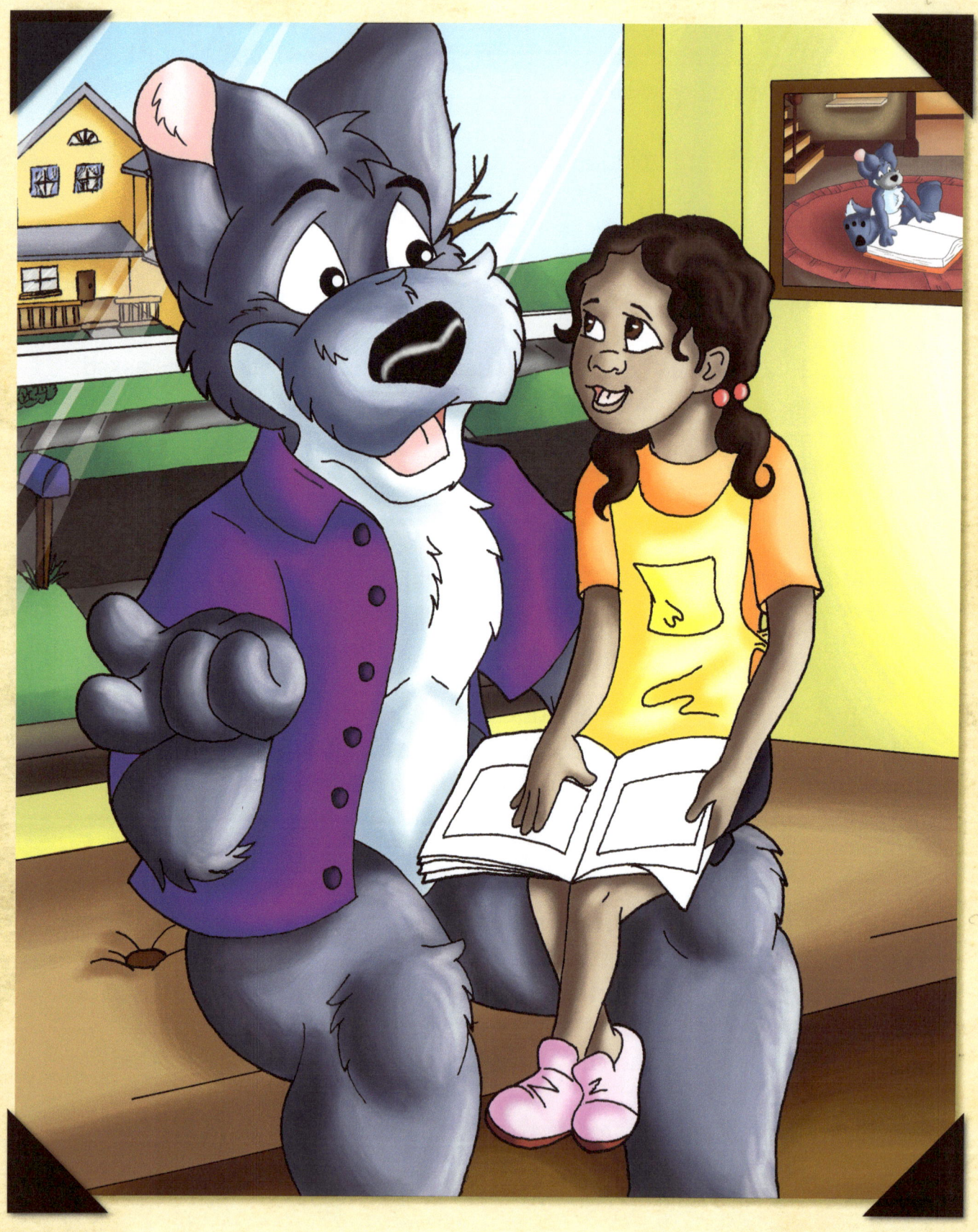

A WOLF'S GUIDE TO ART HISTORY

"It has? How?" Kat asked.

"Well, take the Renaissance for example, and an artist by the name of Da Vinci." He explained as he flipped the pages and pointed to a picture of the artist. "He dreamed up all sorts of new inventions. It was artists and dreamers like him that allowed us to explore our boundaries and create new things that make our lives easier today."

"Like what?" Kat asked.

"Well..." Fenny thought for a moment. "How about helicopters? Da Vinci actually came up with the very first designs for a working helicopter."

"No way!" Kat chirped.

"And, what about Norman Rockwell?" Fenny smirked, flipping a few more pages.

"Who?" Kat responded, unfamiliar with that name. "Was he an inventor too?"

"Well, no. He did art for a lot of magazine covers, and was gifted to be able to tell an entire story in a single picture. He would portray what Americans did in their everyday lives, and it was during some of the most troubled times of our history that he created some inspirational pieces." He explained. "He was even the art director for one of the magazines that I use to get when I was little."

"How do you know all of this stuff, uncle Fenny?" Kat asked curiously.

"Well, maybe we should start at the beginning." He explained. "When I was still just a puppy we lived in downtown Rockburg, not far from the Hopewell Memorial Museum of Art." He chuckled to himself thinking back to that day.

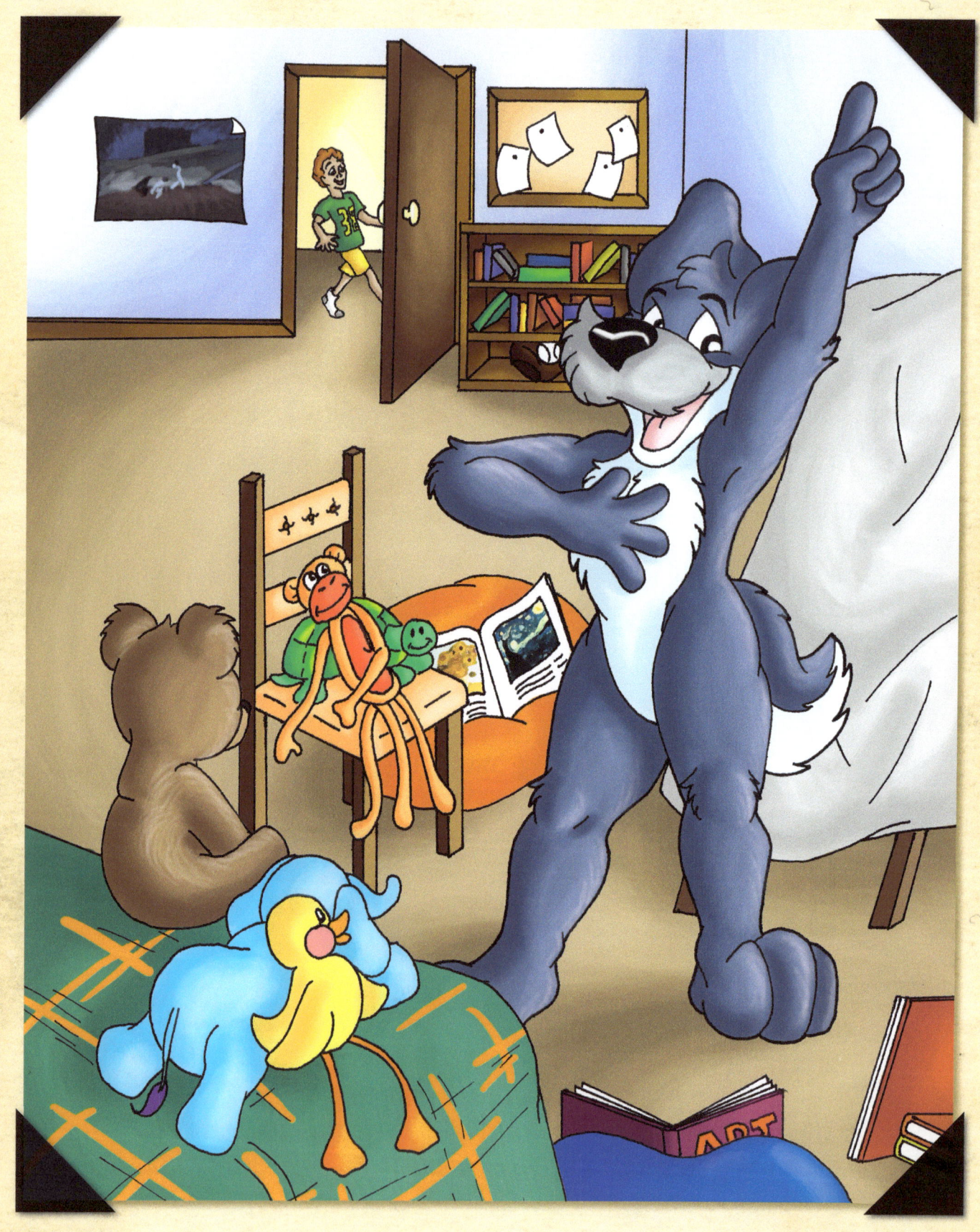

A WOLF'S GUIDE TO ART HISTORY

CHAPTER 2

The crisp autumn wind blew through his window, rustling the curtains as Fenny put the finishing touches on his latest creation. He stepped back, as he admired his work, imagining his painting alongside his favorite artists, like those in the art books his mom used in class.

A mischievous glint sparked in Fenny's eyes as he dashed for his collection of art books. He quickly began to flip the well worn pages to his favorite pictures and set them up around his room. He threw his bed sheet over his painting and, making sure his brother wasn't looking, he setup his stuffed animals around his masterpiece for the unveiling.

Puffing out his chest and raising a hand high, he proclaimed, in his best grown up voice. "Thank you everyone for attending this presti- prestid- presdigi-" Fenny narrowed his eyes in frustration. "This important event!" He announced. "For the first time on display in the upstairs gallery, or as some of you may know it as, my bedroom. We are proud to present a Fenny original, titled... Um... *Untitled!*" Just as Fenny was about to pull the sheet off of the painting he heard snickering at his bedroom door. Fenny turned to glare at his brother who was on the brink of a fit of laughter.

"Don't let me stop you." Jay teased. "But, if we can tear you away from your adoring fans for a few minutes, breakfast is ready." Fenny's ears perked up with excitement as the smell of sausages cooking in a skillet wafted from the kitchen. Fenny chased his brother downstairs, just as he was about to hurry into the living room he heard something.

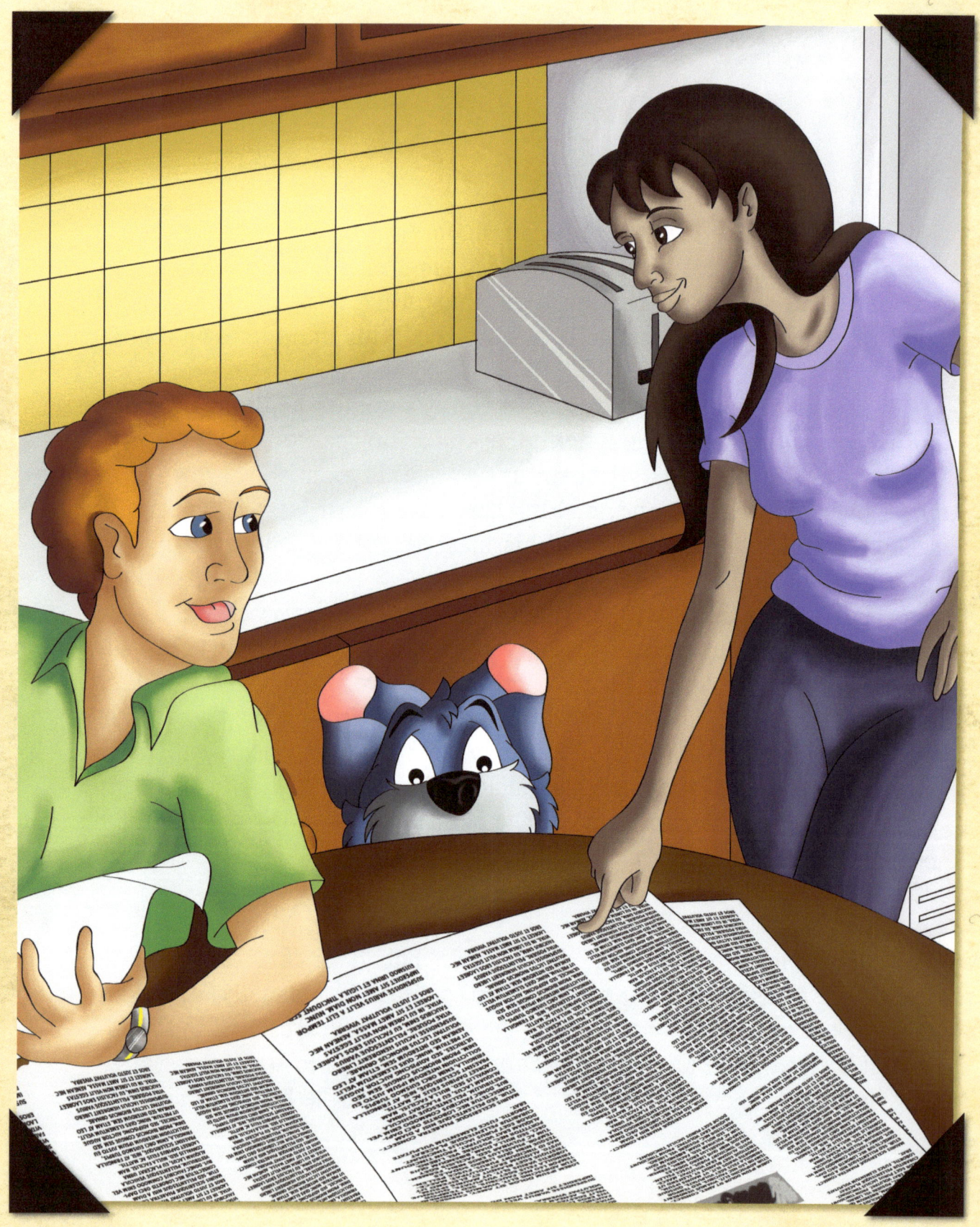

"Oh Dear, did you see the article about the contest the museum is having?" His mom called from the kitchen to Fenny's dad. Fenny stopped right in his tracks, his little ears perking up.

"No, where did you see that?" His dad answered as he flipped through the pages of the newspaper.

"Right here." His mom said as she turned to the front cover. "See, the winner will have their art piece on display in the children's wing, and there's even a secret grand prize too." She explained, just loud enough so Fenny would overhear what she was talking about. Fenny couldn't believe his ears, this was his chance. Fenny's tail wagged excitedly as a grin formed on his face as he thought.

"My painting has a chance to be hung in the museum! I can enter the contest, what a way to surprise Mom and Dad!" He raced into the living room and grabbed that section of the newspaper before hurrying back upstairs. His mom and dad exchanged a knowing smile between themselves.

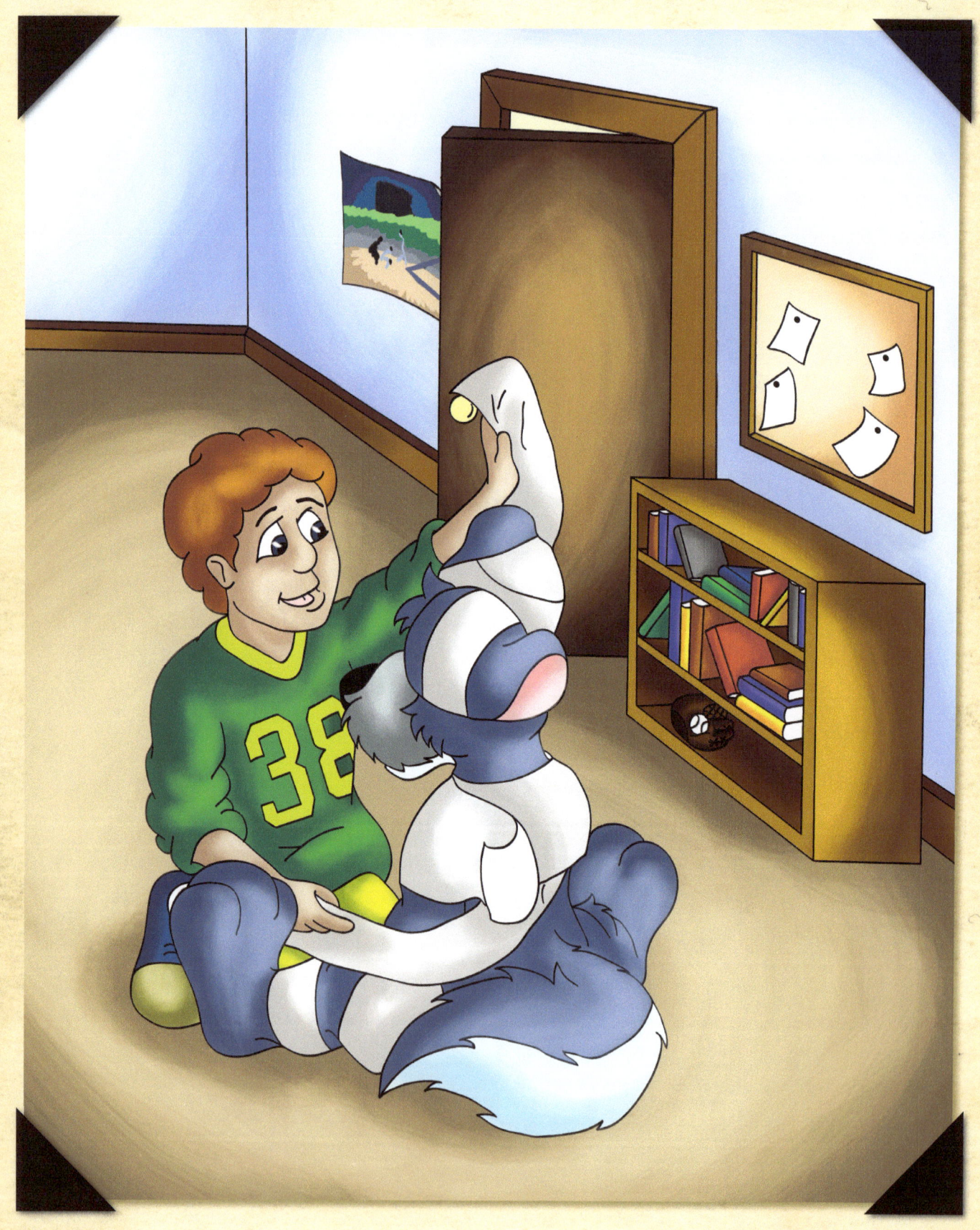

A WOLF'S GUIDE TO ART HISTORY

There was no time to lose. He had to get his painting mailed to the museum today. He grabbed the package wrap, and some string and tape, and started to try to wrap up his painting to be mailed. A look of dismay crossed his face as the only thing he managed to wrap was himself.

Fenny sat covered in brown paper and string as his older brother Jay passed by in the hall. As he walked by Fenny his eyes widened and he stopped in his tracks. He took a couple steps back and a slow grin formed on his face. "How can such a little pup make such a big mess? Mom should have left you in the woods where she found you." Jay laughed as he looked at the unusual sight. Fenny's ears lowered sadly as he looked down at his painting. "Aw, come on, I'm only teasing, it's my job as your big brother, to pick on you now and then." He said as he started peeling the paper off of Fenny, and untangling him from the roll of string.

"You're only older than me by two years!" Fenny huffed.

"What were you doing anyway?" Jay asked curiously.

"I need to mail my painting to the museum today." He explained. "I wanted to enter the contest and surprise Mom and Dad." Fenny said as he held up the newspaper for him to see.

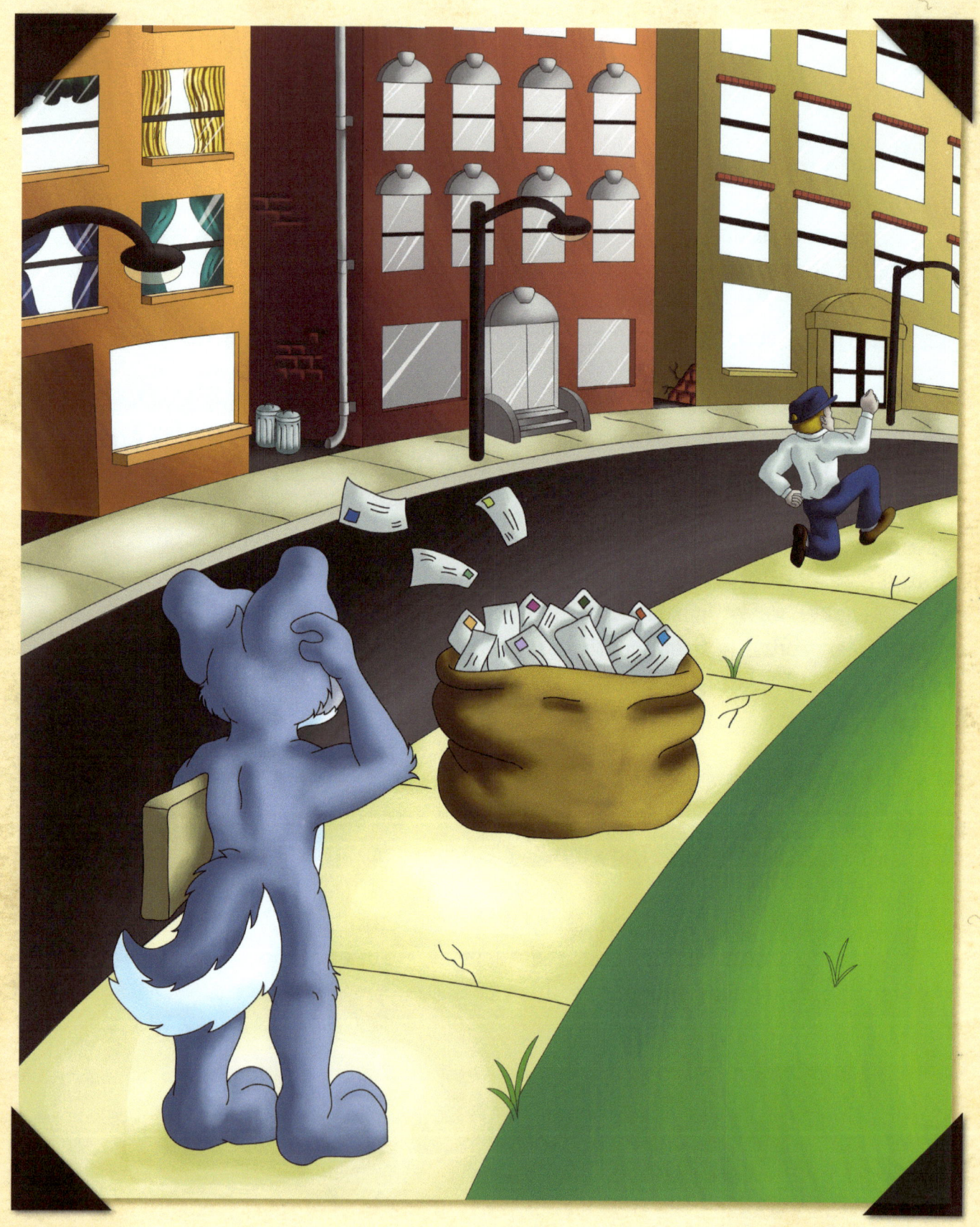

"Well, fur-ball, you happen to be in luck." Jay said with a grin. "I'll help you wrap your painting." He said as he sat down next to Fenny and wrapped his picture up into a little brown package.

"Now you better hurry." Jay told Fenny as he looked up at the big round clock. "The mailman should be coming soon." Fenny's eyes bulged as he saw how late it was. He quickly thanked his brother and hurried downstairs. Stepping out on the porch he looked down the street. The mailman was only one house away. He grinned and ran out with a bark.

"Mr. Mailman." He yelled. The mailman's eyes widened and his skin turned white as he looked up and saw the tiny wolf pup hurrying towards him. He dropped the bag of mail and ran back the way he came. Fenny stopped and watched curiously at the odd old man.

"He must have forgotten to deliver a letter." He thought. "I'll save him some time." With that he picked up the mailman's bag and dropped in his painting to be delivered down the street. He headed home with a smile on his face thinking, "Mom and Dad will be so surprised."

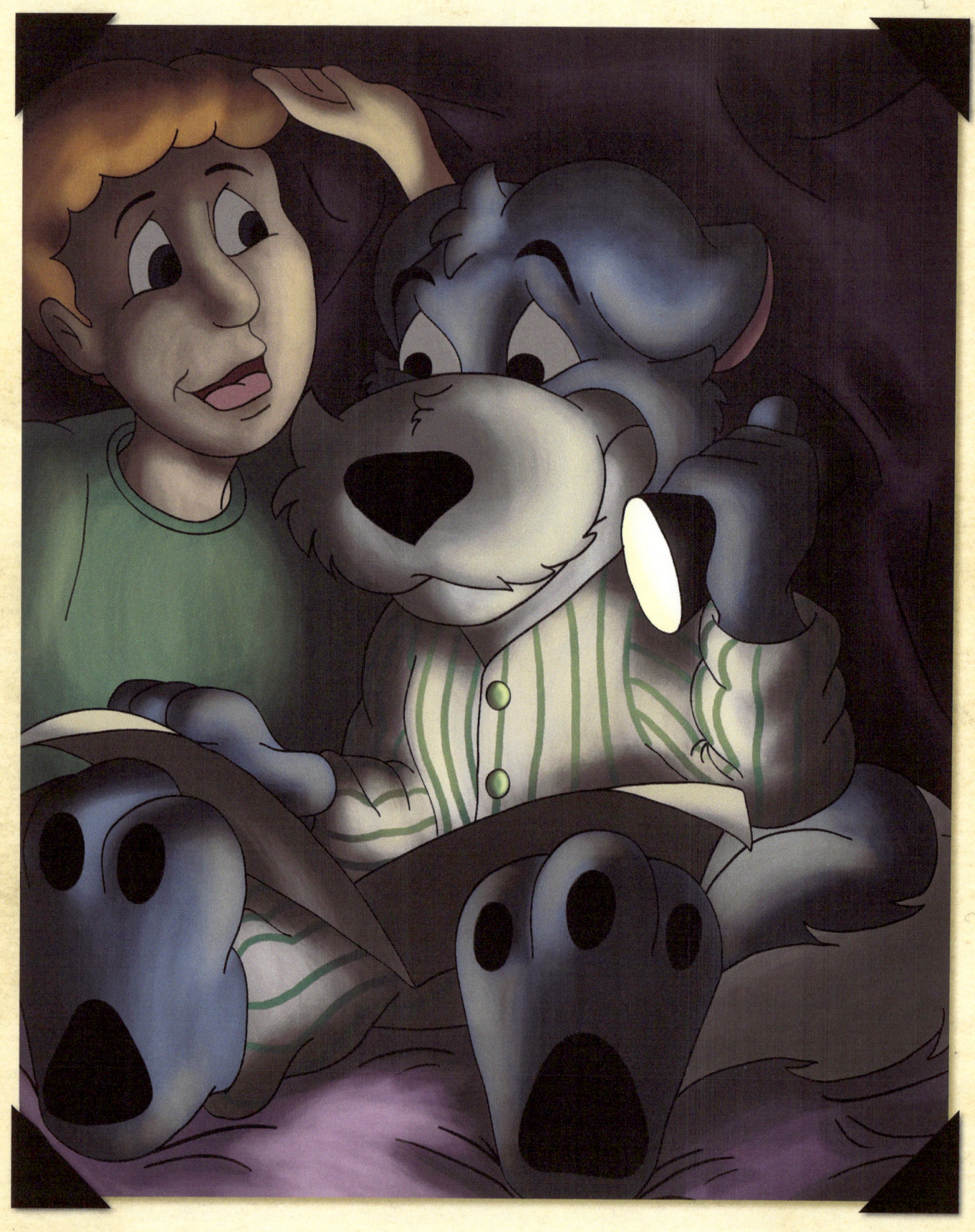
A WOLF'S GUIDE TO ART HISTORY

CHAPTER 3

The week seemed to take forever as Fenny waited anxiously for the day when he'd go down to the museum, and find out if he had won. A smile played across his muzzle at the thought of how proud his family would be to see his painting being hung in a real museum. The longer he waited the more anxious he became.

The night before the big day Fenny sat up in bed with the blanket pulled over his head and a flashlight on underneath; he quietly pulled out the newspaper ad and read over the article again. The contest was open to any child that wished to enter. Fenny knew that meant his little painting would be up against others more experienced than he was, others a lot older, with a lot of training. His ears flattened against his head as he thought to himself. "What chance do I have of winning against real artists?" He whimpered.

"I can't think of anyone with a better chance." Fenny heard Jay proclaim over his shoulder. He turned and pulled the cover off of his head, surprised to find Jay next to him. "I think it's everyone else that should be worried about competing against you." Jay encouraged.

"I thought you said my painting was silly." Fenny said defensively. His ears flattened against the back of his head.

"How many times do I have to remind you, I'm your big brother, it's my job to tell you that." He said, ruffling the fur on his head. "Now go to sleep, you've got a big day tomorrow." Jay whispered as he gave Fenny a hug and climbed back into his own bed. "Besides, you're keeping me awake and I have a soccer game first thing in the morning." Fenny held up the paper one more time.

"Yeah! Look out everyone, there's going to be a new masterpiece hung in that museum tomorrow!" He whispered to himself cheerfully before plopping back into his bed and falling asleep.

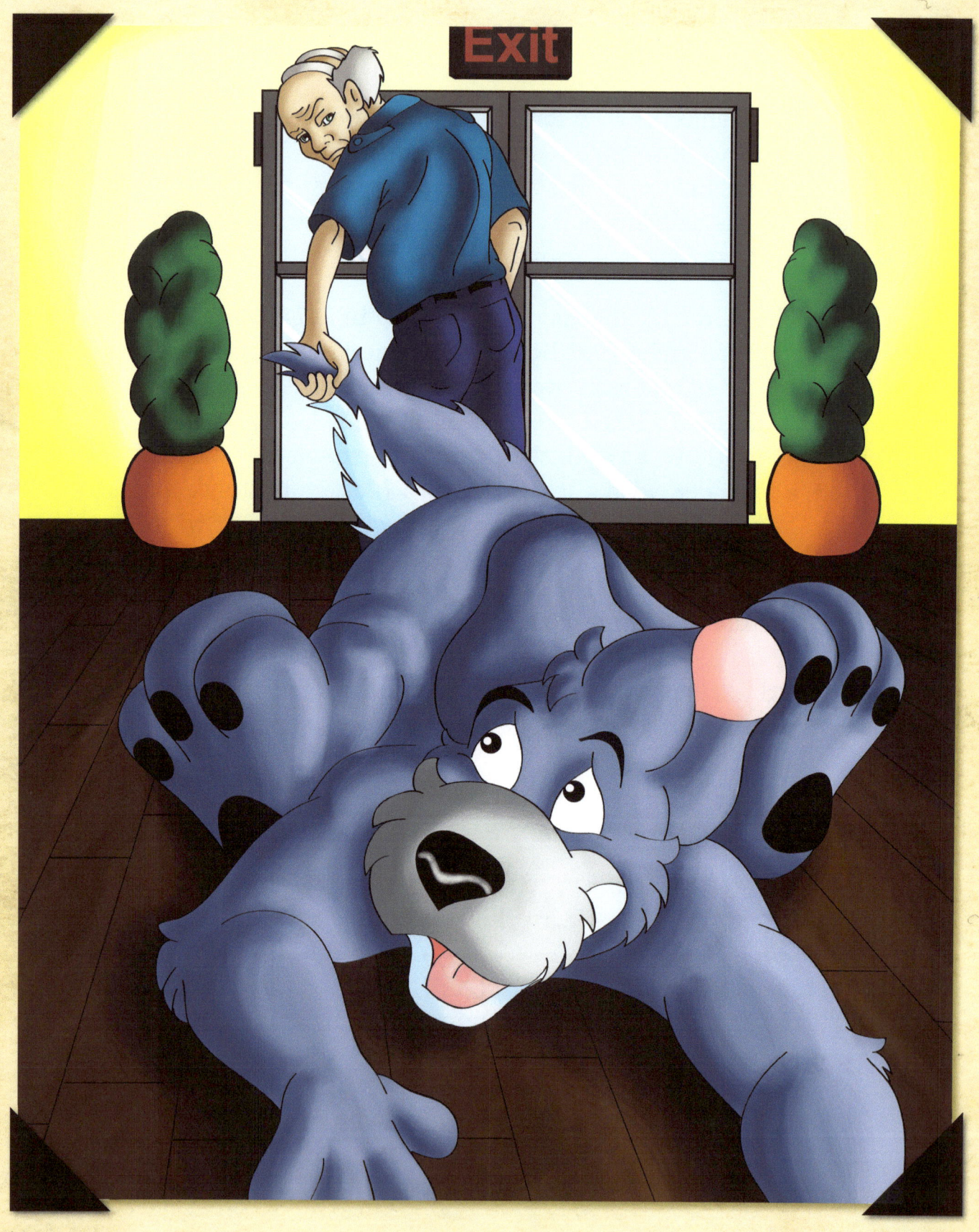

A WOLF'S GUIDE TO ART HISTORY

The next morning Fenny woke up bright and early and headed down to the huge white building. "Hopewell Memorial Museum of Art." He read the sign aloud, hurrying to get inside. As he made his way towards the doors, he passed by a sign, not paying it any care.

"No pets allowed!" He heard a voice yell.

"Pet?" Fenny asked. "What pet?" He yelped himself when a guard grabbed him by his tail and turned in surprise. "But, I'm no pet!" He cried as he was shown to the door, but the guard didn't listen and threw him back outside. As he dropped Fenny at the bottom of the steps, he glared at a single strand of Fenny's fur on his sleeve. "Keep your filth and your fur out of my museum." He snarled.

"But, I have to get inside. I want to find out if my painting is being hung." Fenny said as he turned to face the man keeping him from getting into the museum. He seemed to shine from the top of his bald head, to his freshly shined shoes. The guard began to laugh.

"Your painting will never hang in here! This museum only hangs the greats, not... finger paints..." He said in a mocking voice and turned back in. Oh, but Fenny is a clever pup, and was determined to get a chance to see the art he loved so much. He got right back up, shook the dust off his tail, and found a way past that guard.

A WOLF'S GUIDE TO ART HISTORY

Once inside, he looked around in awe of all the beautiful pictures hanging on the wall. The smell of the oil paints tickled Fenny's sensitive lupine nose. His ears twitched at the sounds of his footsteps echoing in the enormous rooms. The lighting was dimmed and elegant. Even the massive hallway gave off an air of grandeur. Fenny felt so small as he stood in the enormous hallway. There was so much there, not just paintings, but sculptures, etchings, and so much more to see.

"Where to start?" He wondered aloud.

"And, now if everyone will follow me, we'll begin our tour." Fenny's ear turned towards the voice of a kind young woman, dressed in a teal and gray uniform, typical for the museum's tour guides.

"Tour?" Fenny perked up at the opportunity and followed the small group through a giant set of doors. Inside there were paintings on the walls with lights shining down. His eyes widened and his muzzle formed a smile. In the middle of the room was a big wax display showing the artist himself at work. The lady in the uniform motioned towards the figure and began to speak with a voice of authority and experience.

"Here we have Jan van Eyck, an artist who revolutionized the world of oil painting with new effects." The tour guide explained as the crowd gathered around the wax figure. Meanwhile, Fenny was busy looking at all of the works of art that the artist had created. "Jan van Eyck painted realistic paintings, abandoning the classic styles. Can anyone here tell me what this meant for the process he used?" She asked the crowd. Fenny thought back to his books back home, then looked back at the paintings on the wall.

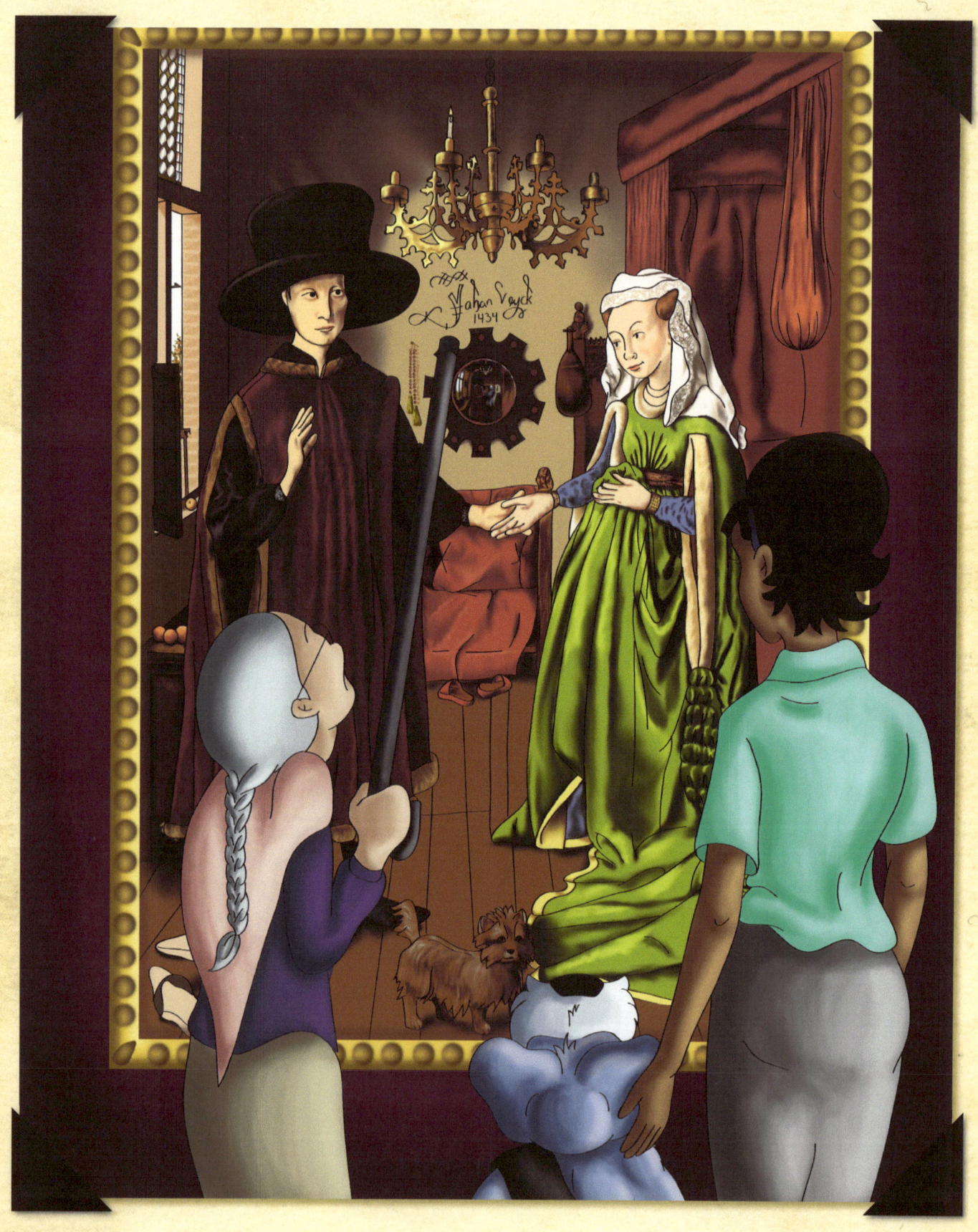

A WOLF'S GUIDE TO ART HISTORY

"I know!" He suddenly exclaimed.

"Yes?" The tour guide asked as everyone turned to look at the pup that had followed them in. "It meant that he would paint his subject just like he saw them, rather than an idealis.. ideali..." Fenny had always had a hard time pronouncing that word.

"Idealistic?" The tour guide offered.

"Yeah, that's it." He smiled.

"I'm very impressed. That's right. He painted the subjects exactly as he saw them. Before this paintings were more decorative than natural. During this time, the painting and the frame were usually painted at the same time." The tour guide continued. "Now, unlike other artists, Van Eyck would sign his name on the frame rather than on the painting itself, however here we have an exception to that rule." She said as she walked over to the exact painting Fenny was looking at. "*The Arnolfini Portrait.*" She introduced, looking down at the little wolf in front of her. "In this painting he actually wrote in his language, what we would translate as something along the lines of, Jan van Eyck was here, 1434." She explained.

She then turned towards the rest of the crowd. "Can anyone here find where he wrote that?" She asked, inviting the rest of the tour group to take a closer look. Fenny had seen the painting many times in his books of art back home, but he had never noticed anything like that. It was an older lady in the crowd that finally pointed it out.

"On the back wall in the center of the painting." She said as she pointed with her cane. Fenny looked closer, she was right, it was words that he didn't quite understand, but sure enough there was the artist's name.

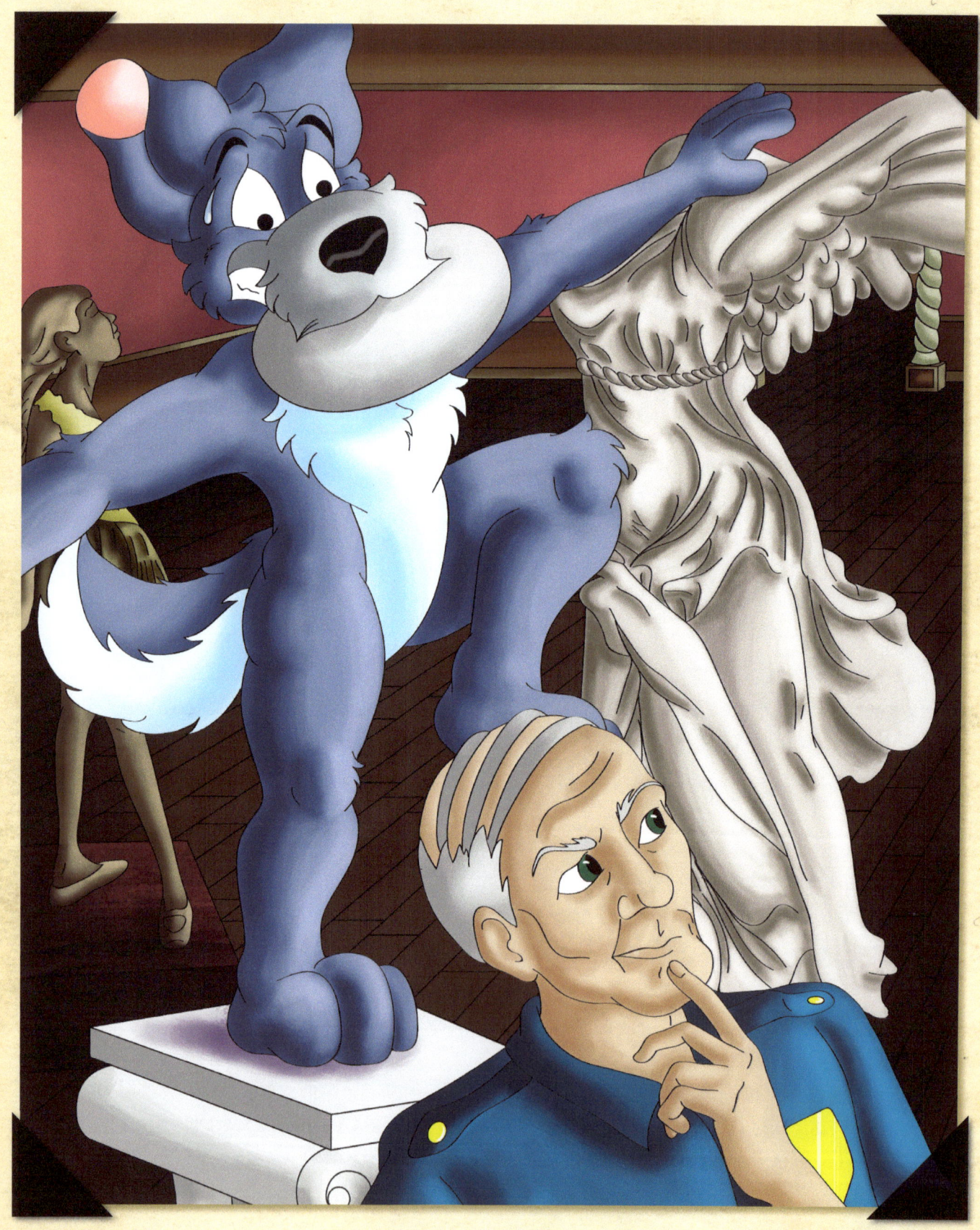

A WOLF'S GUIDE TO ART HISTORY

"Wow." He thought to himself. "I never even noticed... I'll have to look much closer from now on."

"Now, if you'll follow me, we'll move on." The tour guide said as she led the group into the next room. Fenny stayed for a moment longer to take a closer look at some of the paintings, a decision he was soon to regret. His ears flattened against the back of his head as he heard.

"Stop! There's no pets allowed in here!" With a glance over his shoulder, he saw that grumpy old guard running fast.

"No, I've come too far to give up now." He thought as he took off like a shot. He hid away in another hall, among great statues, posing on a pedestal and wiping away a bead of sweat from his brow, and the guard... he didn't notice at all.

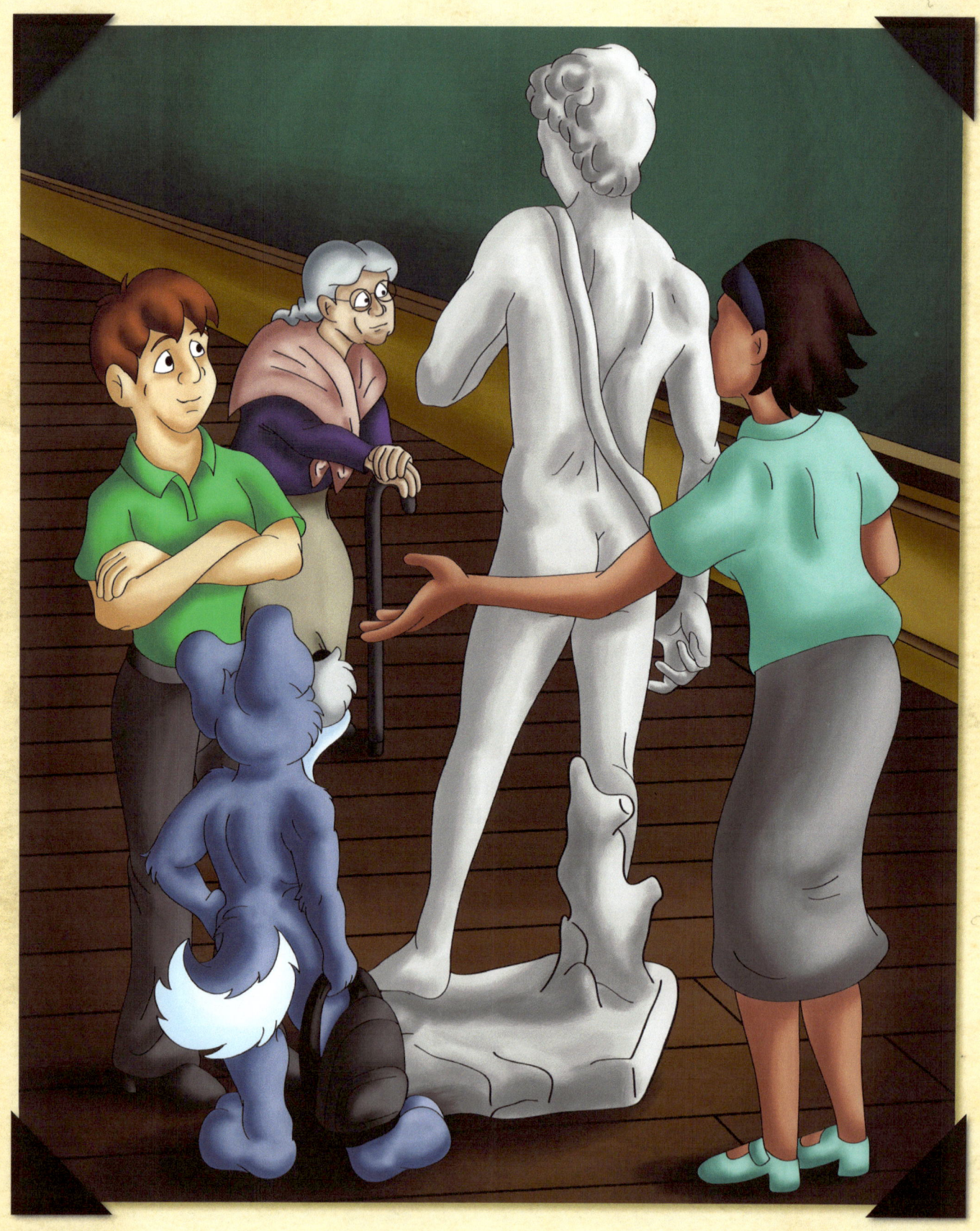

CHAPTER 4

"I have to be more careful." Fenny thought as he climbed out, making sure the coast was clear before taking a look around. These statues, he knew them from somewhere. There were lots of paintings in here as well.

"And, in this room we have the works of the great painter and sculptor Michelangelo." He heard the familiar voice of the lady tour guide as she led the group into the next room. "Two of his greatest sculptures he completed while he was still very young. *The Pietà* was completed when he was only 23 years old." She explained. "Can anyone take a guess what other famous sculpture I might be referring to?" She asked the group. Fenny turned to listen to the lesson she was giving.

"*The David?*" A boy about the age of Fenny's brother took a guess.

"Very good. *The David* was from the story of David and Goliath and was done by the time he was only 29 years old. This sculpture was carved from a huge block of marble that people referred to as the giant, before it was carved." She explained. Fenny moved closer to hear a little better.

"*The David* also exhibits a form called *contrapposto*. This means your shoulders and hips slant in the opposite direction in a pose." She glanced around, and once again, brought the attention back to Fenny. "Much like our little friend here is doing now." She said. Fenny blinked and glanced at how he was standing. He had a hand on his hip, his shoulders slanted one way, and his hips slanted the other way. She was right! He had become more relaxed by now and it showed in his posture.

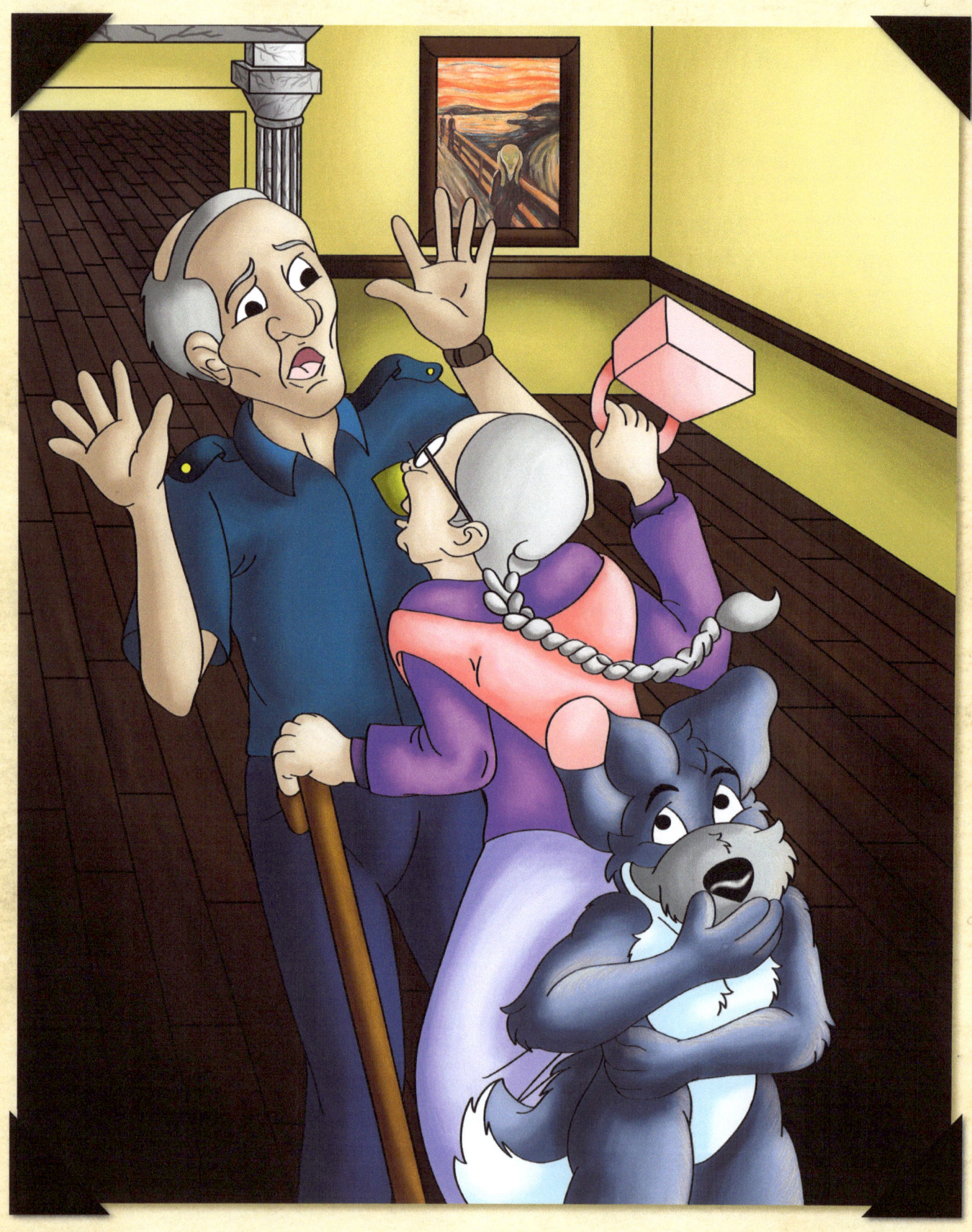

A WOLF'S GUIDE TO ART HISTORY

"And, if everyone will look up we find our artist hard at work on one of his most famous pieces." She said as she directed their attention towards the ceiling of the museum. At the top of a tall scaffold was a wax figure of the artist laying on his back painting the ceiling!

"*The Sistine Chapel.*" Fenny whispered in awe. He looked up at the huge reproduction that had been painted on the ceiling. "Wow, and I got in trouble for painting on the walls…" Fenny murmured to himself.

"You again!" He heard the guard snarl. "I thought I ran you out!" The rest of the tour group turned to look at the guard as he started towards Fenny.

"Uh oh!" He had to think quickly. He grabbed the velvet ropes in front of one of the paintings and set it up around himself as quickly as he could. When the guard reached for Fenny he was surprised to receive a hit over the head from a lady's purse!

"No touching the art!" The little old lady yelled at the guard as she smacked him again with her purse. Fenny stood with his tail wagging and a sly grin on his muzzle as his new friend chased off the guard, continuing to whack him with her purse.

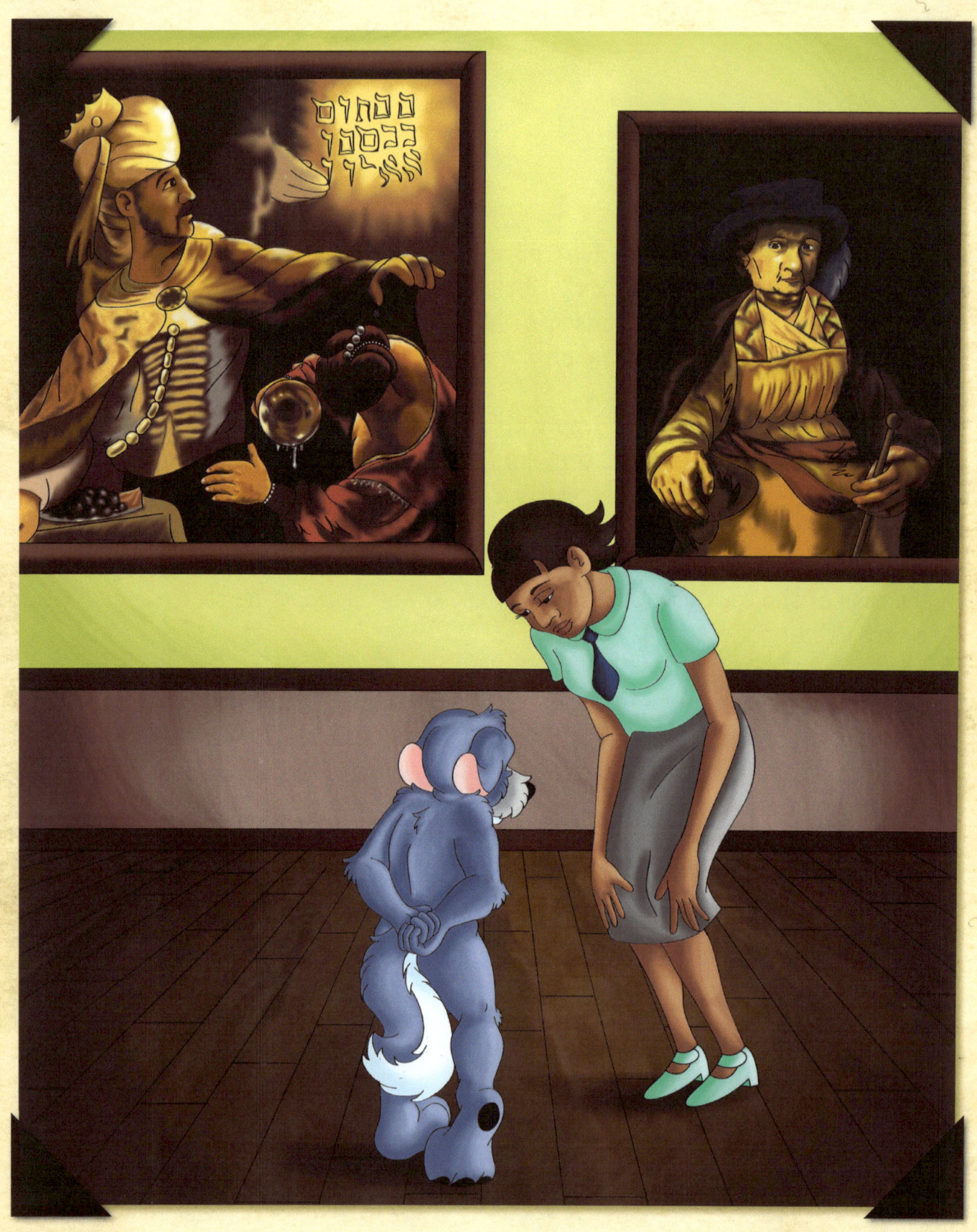

CHAPTER 5

When the guard was gone Fenny slipped off, and headed upstairs in a room, whose paintings focused a lot on light, he hid in there from the guard, safely out of sight. His escape didn't go unnoticed though, as the tour guide followed him up.

"Ah, I see you found Rembrandt Van Rijn." The lady smiled as she found Fenny looking up at the wax figure of the artist.

"Who?" Fenny asked as he turned towards the lady.

"Don't tell me such a clever little pup has never heard of Rembrandt." She said in surprise. "Rembrandt mastered the art of chiaroscuro."

"Chiro-what?" Fenny blinked. "You mean those cinnamon things my mom buys when we go to the fair?" He asked thinking about the sweet fried Mexican treats. The guide chuckled.

"Not Churro." She corrected. "Chiaroscuro." She explained. "You say it like this: key-are-o scoo-ro." She said slowly, trying to make it easier for him to pronounce.

"Oh." He said. She brought Fenny over to one of the paintings. "You see, the way he created his art became a new direction in how art was expressed." Fenny cocked his head curiously. "It's very hard to master, and Rembrandt was very good at it. He created forms through the use of light and shadow, usually, he'd use lighting to make the most important parts of his painting stand out and draw the attention of the viewer." She explained, then knelt down and looked at the pup. "Why is our security guard after you?" She asked. Fenny's ears folded back and he tucked his tail between his legs.

"He says pets aren't allowed in the museum, but I'm not a pet!" Fenny protested. "I have a piece of art in the contest, and I'm trying to find out where it is." The tour guide smiled.

"It seems you came to the right person. My tour ends where the award will be presented. You can follow us." She said, taking Fenny by the paw.

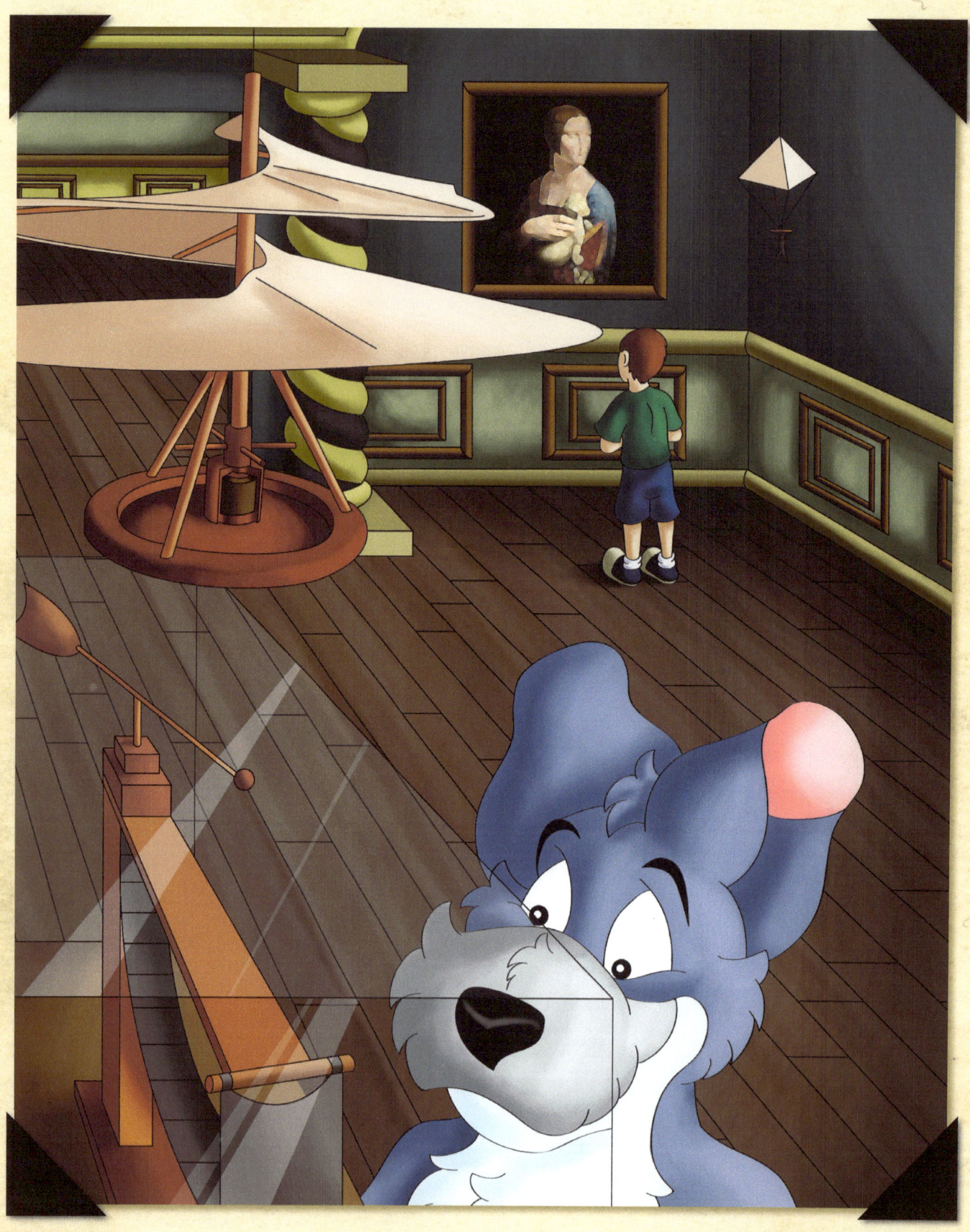

A WOLF'S GUIDE TO ART HISTORY

CHAPTER 6

She brought him to the next room, where the rest of the crowd had gathered. This room was filled with paintings, drawings, and sketches of the human form. His eyes brightened as he stood looking upon some of the most famous works of all. There were models of contraptions Fenny had never seen. More than any so far this artist drew on Fenny's playful imagination. There were early designs for submarines, helicopters, and parachutes, as well as other contraptions Fenny didn't understand just yet. "Who is this?" He asked aloud as he approached the wax figure.

"You're about to find out." The tour guide said as she gathered the crowd around. "Leonardo Da Vinci." She introduced. "The renaissance man, Da Vinci was a master of art and science. Before we begin to talk about this specific artist, let me ask you, does anyone know what the word Renaissance means? Perhaps our little artist can tell us?" She asked Fenny. His tail flicked as he thought for a moment. Fenny's ears flattened against the back of his head.

"I... I don't know, actually." He admitted. "No one ever explained that to me."

"I know." A young woman wheeling a stroller spoke up. "This was a time when people were doing a lot of different learning and studying, and creating all kinds of new art, not just like what you see here, but plays, music, and poetry." The tour guide nodded in agreement.

"This was the time of great scientists, philosophers, poets, and writers, like Shakespeare, Michelangelo, Botticelli, Martin Luther, and of course, as I mentioned earlier, the Renaissance man himself, Leonardo da Vinci." The tour guide added motioning toward the figure of the artist. "Can anyone take a guess what he is most famous for though?" She asked the crowd. The little old lady spoke up again, as she adjusted her glasses.

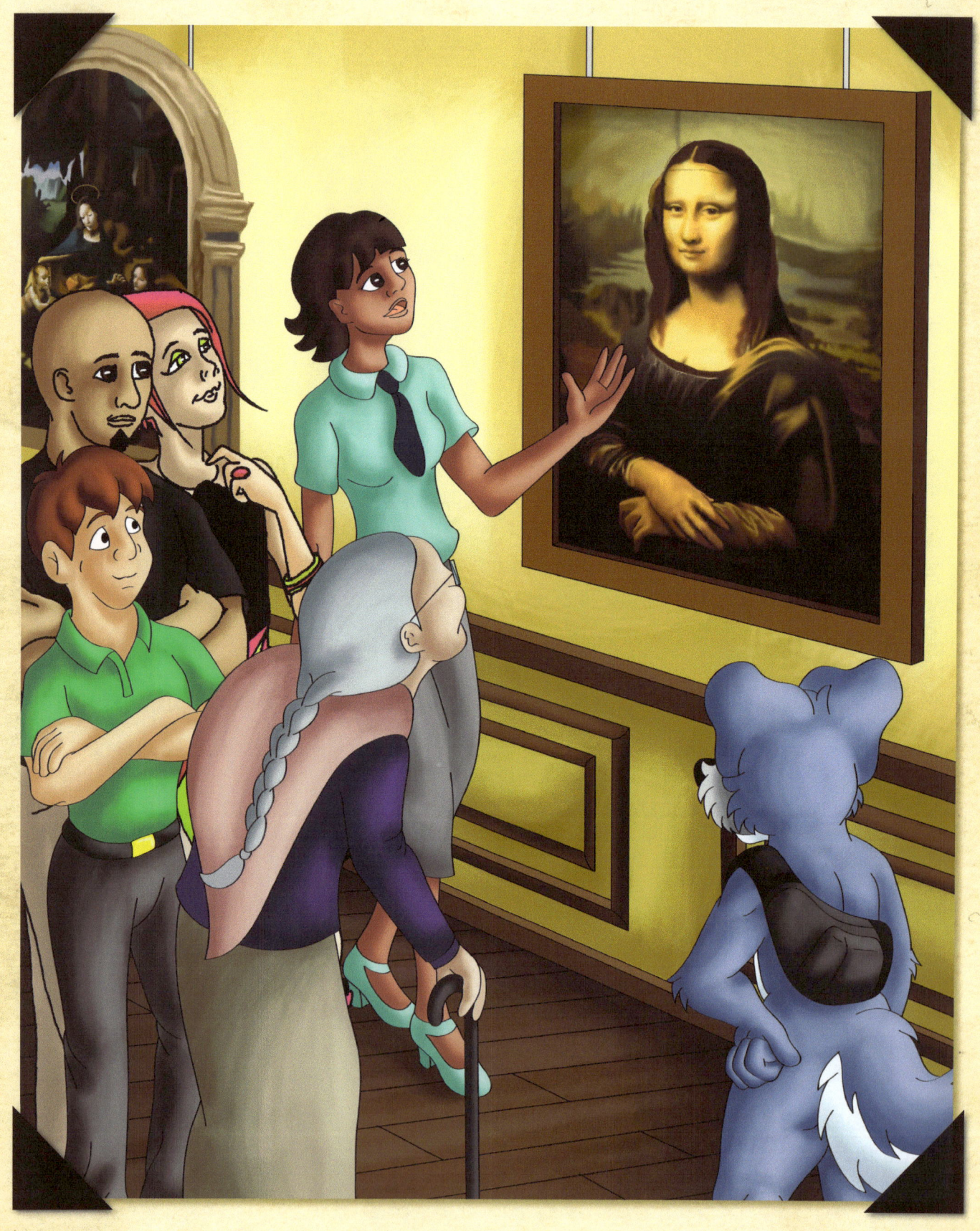

A WOLF'S GUIDE TO ART HISTORY

"*The Mona Lisa.*" She answered. Fenny grinned from ear to ear. He remembered that painting from his book back at home. It was a picture of a lady in a veil, which Fenny always got a good chuckle out of, thinking about how her smile reminded him of a cat that caught a canary. Maybe that's how his mom always knew when Fenny himself had managed to get into the cookie jar?

"Very good, anyone else?" The tour guide asked.

"*The Last Supper.*" An older gentleman in a plaid shirt, offered. "The one with Jesus sitting with his friends at a long dining table." He described it.

"Excellent, I have a very smart group today." She said. "He painted with a style known as sfumato, meaning lost in smoke." She explained as she turned to Fenny. "Can you guess why?" She asked.

Fenny looked at the painting, studying it closely, all the times of looking through his books at home were really starting to come in handy.

"Because of the way the background fades away?" Fenny asked.

"Outstanding." She praised. "He would create an illusion of depth by blurring and using less detail in the background as well as adding a more bluish haze, and using more clearly defined images and details as the subjects were closer in the painting." She explained. "Leonardo Da Vinci loved to learn about how things worked, and about anatomy." The tour guide continued. "He also created a great many designs of machines that we use in our own world today."

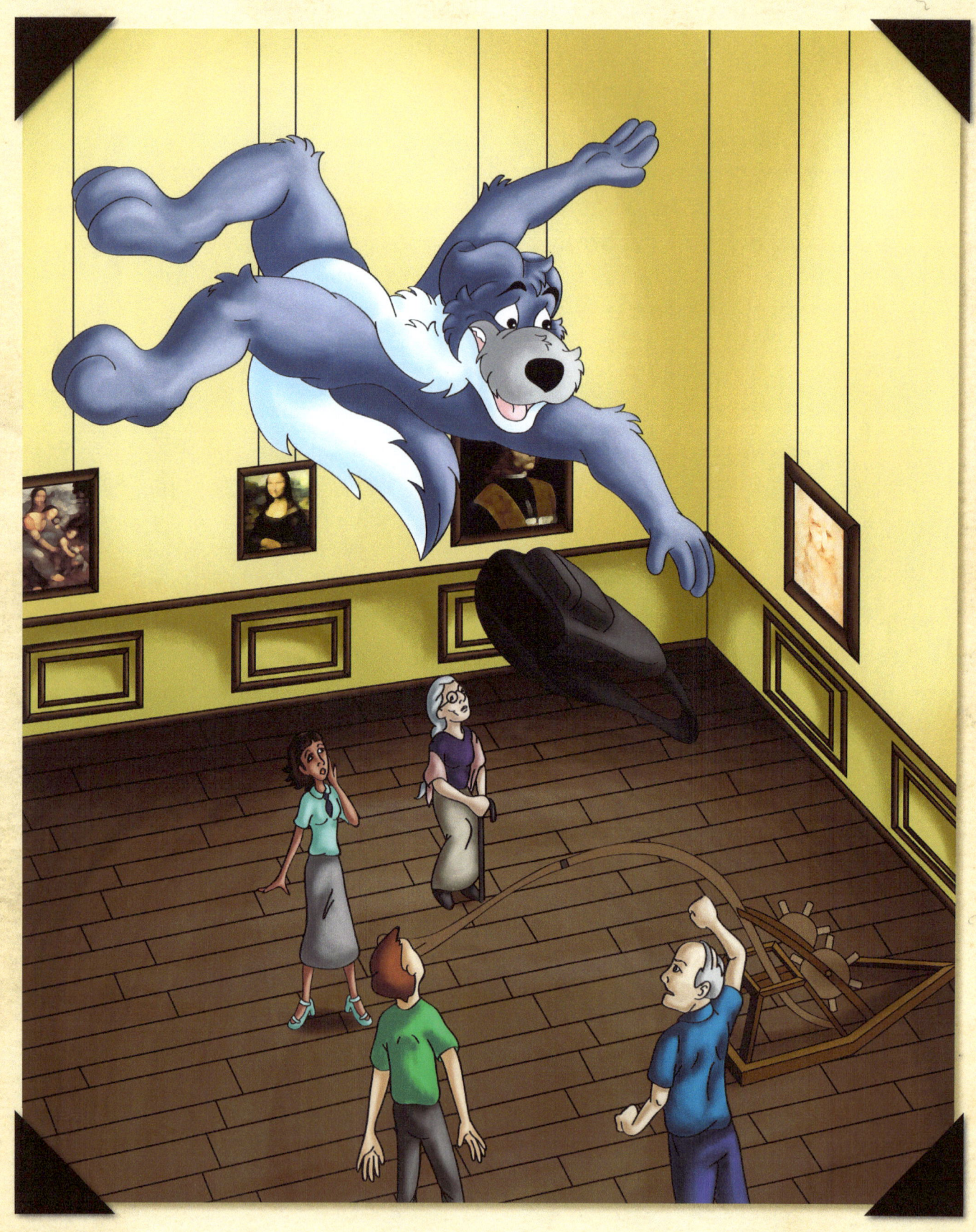

A WOLF'S GUIDE TO ART HISTORY

"It's the end of the line now, mutt." A voice suddenly interrupted the group. Fenny turned and looked in horror as the guard grinned wickedly as he approached. That pup started to back away, climbing up onto a wooden platform, trying to distance himself from the approach guard.

"Now that is quite enough!" The tour guide stepped in front of the guard. Fenny blinked in surprise. "I've seen just about enough. That pup has done nothing wrong!" She protested.

"That mangy mongrel doesn't belong in here, there are no dogs allowed. The last thing I need is some flea-bitten mutt chewing on the displays!" The guard growled.

"I'm not even a dog!" Fenny yipped. "I'm a wolf! And, I haven't chewed on anything since I was teething. Mom even said she didn't like that chair very much anyway." The guard stepped passed the tour guide and started to climb up towards Fenny.

"You'll knock something over with that blasted tail of yours!" The guard barked. Just when he thought the guard had him trapped, something went 'snap'. As the guard looked down to see the lever he had leaned on, Fenny was already flying through the air, as the catapult flung him down the hall.

"Dang da Vinci dog..." The guard groaned.

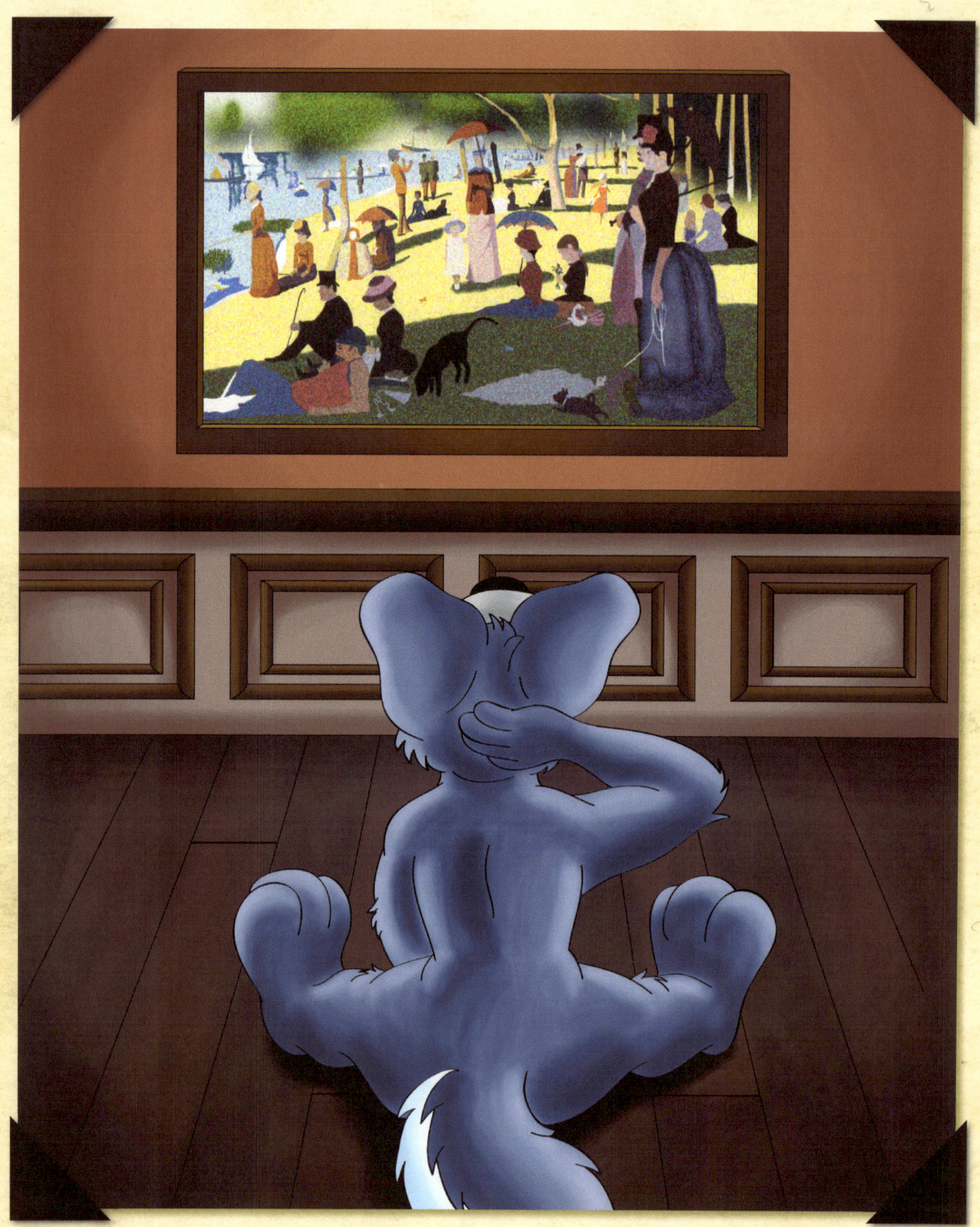

A WOLF'S GUIDE TO ART HISTORY

CHAPTER 7

As Fenny landed with a thud he glanced back, now safely out of sight. He looked around finding a new room of art. "I must have hit my head." He thought to himself. "I think I'm seeing spots." He began looking closer, and blinked his eyes so wide when he realized the entire painting was made of dots, lots and lots of dots. He looked around the room at all of the paintings.

"This way now, class." Fenny heard a voice. He turned to find a teacher leading his class through the exhibit, explaining about the artist. "Here we see Georges-Pierre Seurat." The teacher said as he motioned to the wax figure in the middle of the room. Fenny got up and ducked behind one of the exhibit pieces, as he listened curiously. "Seurat, as you all have studied in the last few weeks, was the founder of Neo-impressionism, and his masterpiece *Sunday Afternoon on the Island of La Grande Jatte* is considered an icon of 19th century painting. As you can see, his work consisted of lots and lots of dots to make his painting." He stepped aside to let the students take a closer look, "As you can see, the entire painting is made up of tiny dots of multi-colored paint, that lets the eye blend the colors rather than having the colors blended by the artist. This one painting took him two years to complete." Fenny blinked a bit.

"And, I thought spending a whole afternoon on a painting was a long time..." He murmured to himself. "Speaking of time, I need to get going, or I'll miss the award ceremony." He said as he looked at the time, and hurried off looking for the tour group he had been with earlier.

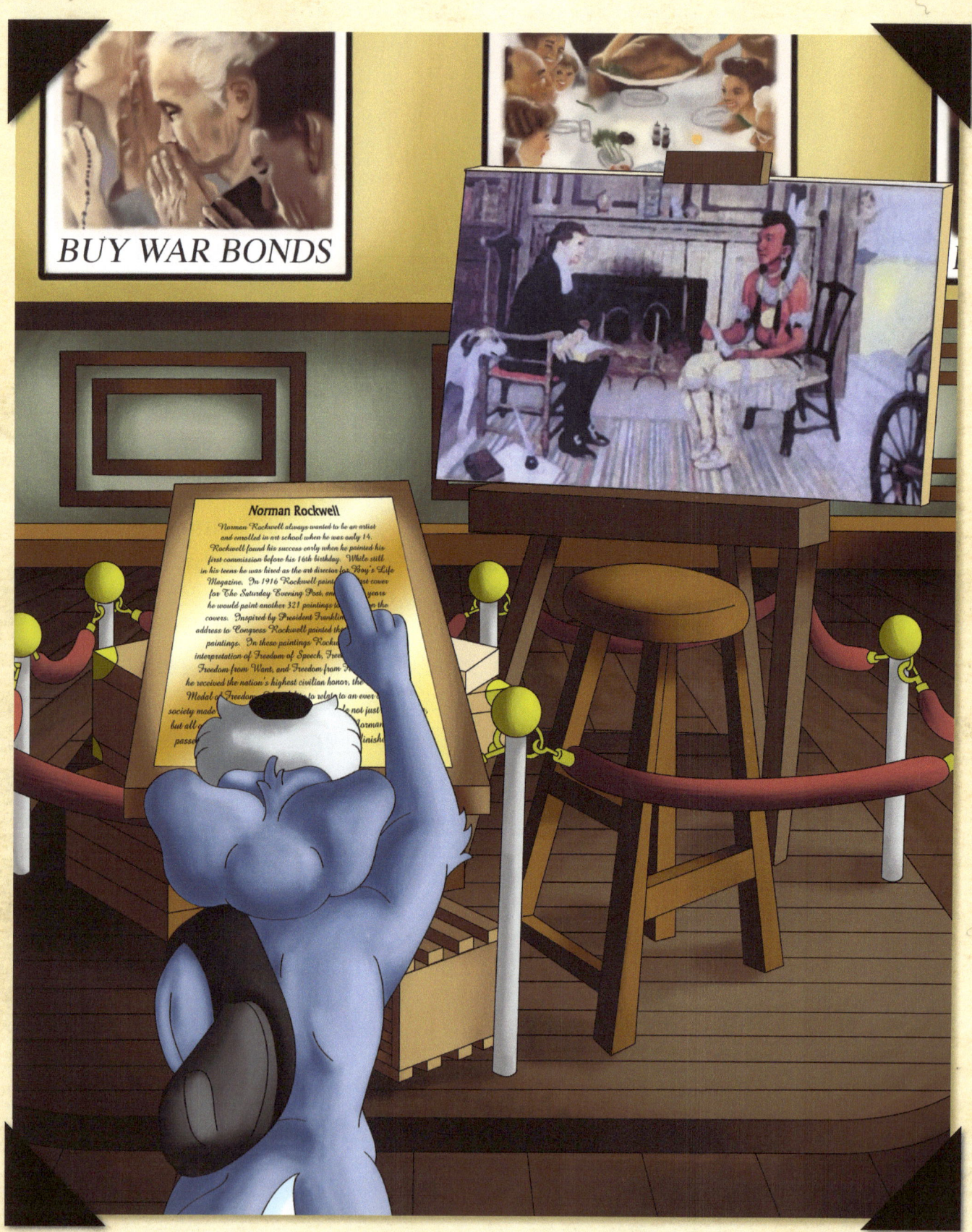

CHAPTER 8

Fenny stopped in the next hall as he found himself looking at paintings that drew him in, and made him want to see more. On the walls were paintings that reminded him of the storybooks back home. Each one told a story, some funny and whimsical, others more somber and thoughtful. This room was displayed a little differently too. He looked at the stand in the center of the room where the wax figure of the artist should have been. Instead there only stood a lonely easel with an unfinished painting resting on it.

He moved towards it curiously, finding there, a big gold plaque. "Norman Rockwell..." he read "...always wanted to be an artist and enrolled in art school when he was only 14." Fenny smiled with excitement. "He always wanted to be an artist too!" He exclaimed.

"Rockwell found his success early when he painted his first commission before his 16th birthday. While still in his teens, he was hired as the art director of *Boys Life Magazine*." Fenny knew that magazine, he got a copy in the mail every month. His little tail wagged faster the more he read. "In 1916 Rockwell painted his first cover for *The Saturday Evening Post*, and over the years he would create another 321 paintings to appear on the covers. Inspired by President Franklin Roosevelt's address to Congress, Rockwell painted the Four Freedoms paintings. In these paintings Rockwell painted his interpretation of *Freedom of Speech, Freedom to Worship, Freedom from Want,* and *Freedom from Fear.*"

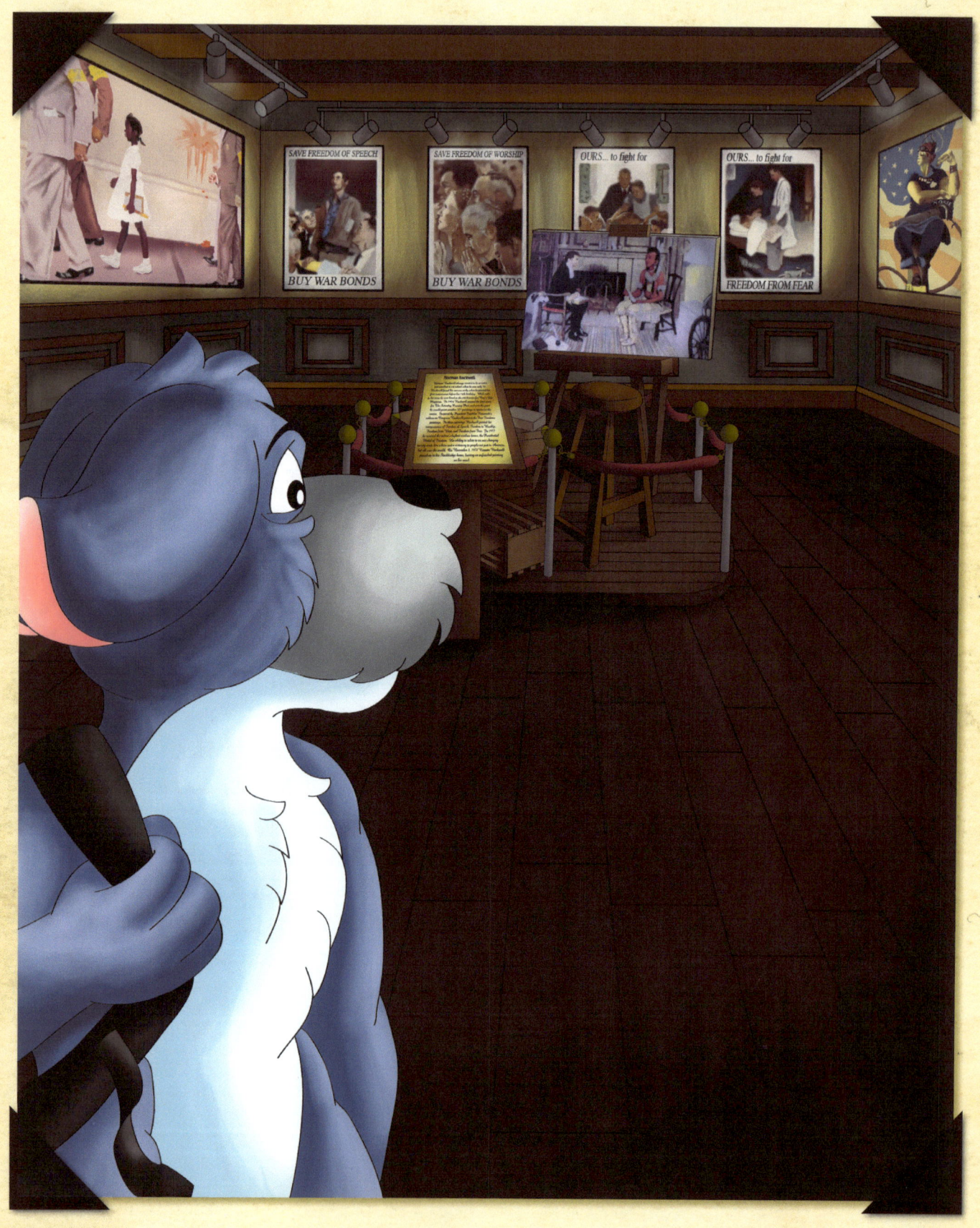

A WOLF'S GUIDE TO ART HISTORY

Fenny looked up, seeing the paintings that were now on loan to the museum. He thought about how they still seemed to fit with how his own family lived each day. "In 1977 he received the nation's highest civilian honor, the Presidential Medal of Freedom. His ability to relate to an ever changing society made him a hero and a visionary to people not just in America, but all over the world." Fenny's mind raced now thinking about all of the work that this artist had done for so many people.

"Wow." He thought to himself, his ears folded back solemnly as he finished reading the big gold plaque. "On November 8, 1978 Norman Rockwell passed on in his Stockbridge home, leaving an unfinished painting on his easel." He looked up at the unfinished painting in the center of the room right in front of him. An inscription in gold was on the edge of the easel.

"Without thinking too much about it in specific terms, I was showing the America I knew and observed to others who might not have noticed. -Norman Rockwell" It read. He stood there silently for a moment as he thought about that. He slowly turned and wiped away the tear rolling down his cheek. Before he left the room he turned back one more time and looked at the lonely unfinished painting. "Thanks for everything." He said quietly before slipping out of the room.

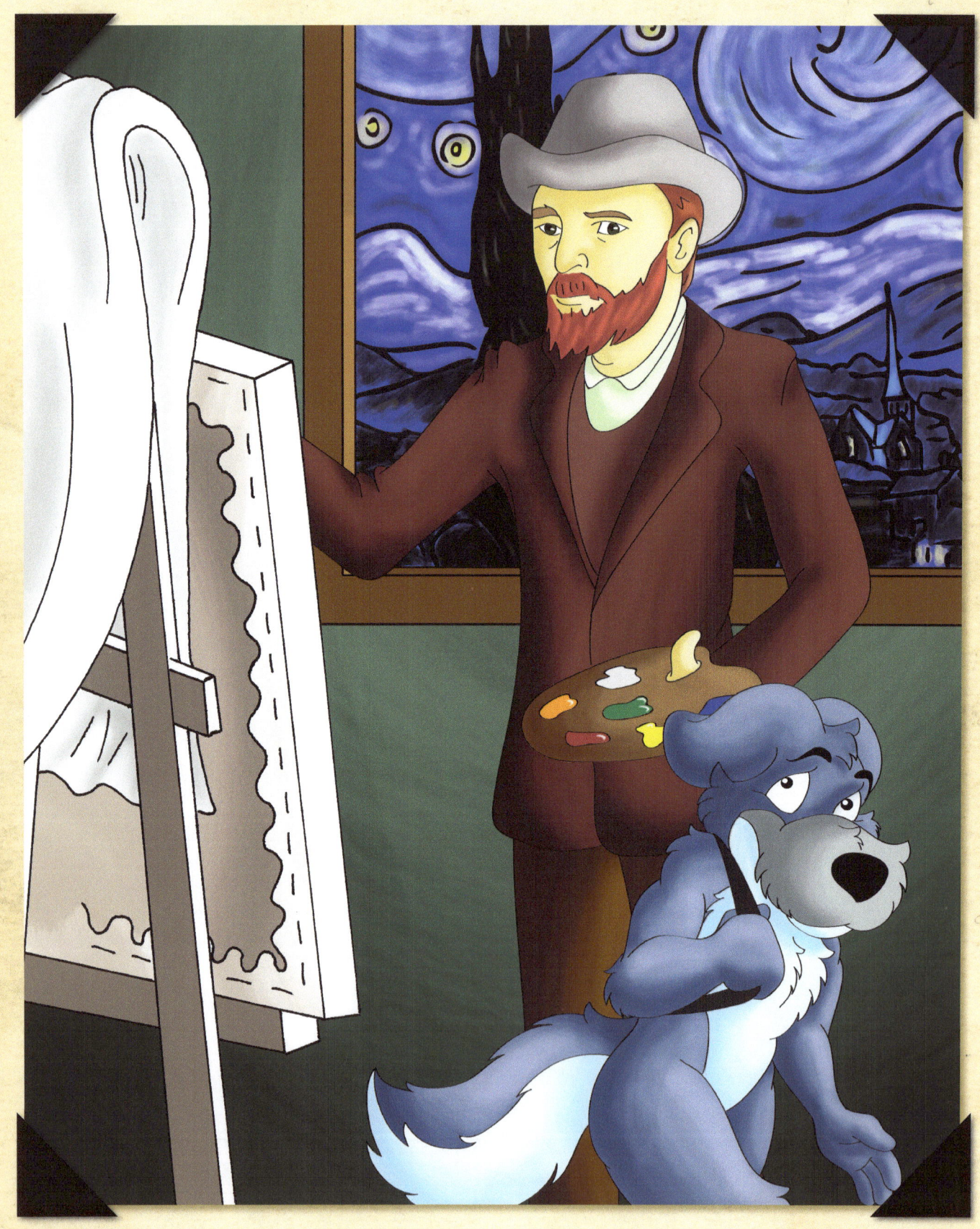

A WOLF'S GUIDE TO ART HISTORY

CHAPTER 9

Fenny finally came to a stop further down the hall, this room was very bright. Colors danced in the paintings he saw, stirring the emotions. One painting made him feel happy, another made him feel sad. "There's something different about these paintings he thought, something doesn't seem right." He looked at the wax figure in the middle of the room. Something in the artist's eyes made him take a step back in fear.

"You seem to have found your way to Vincent Van Gogh." He heard a deep menacing voice echo through the hall. He turned with a start.

"Who said that?" He exclaimed looking around, but finding no one else there.

"This is one of my favorite artists." There was that voice again. He carefully took a step back. "He was insane you know." Fenny was trembling with fear, that voice... he had heard it before, but couldn't place where. Fenny knew this artist. He had seen his paintings before.

"Is... is that so?" Fenny stuttered. "What do you call it?"

"Expressionism." The voice echoed again.

"W-wh-what does that mean?" He asked, still shaking with fright.

A WOLF'S GUIDE TO ART HISTORY

"It means he painted how he felt about what he saw, instead of what was really there, like in *The Starry Night*." Fenny looked up at the painting. The colors swirled on the canvas wildly, what kind of state must he have been in to paint such a picture? Fenny already knew from reading about him back home.

"And, do you know where he painted it?" Fenny asked boldly.

"An asylum." The voice whispered menacingly right in Fenny's ear this time. He turned and let out a yelp that could be heard down the halls as he turned and found himself face to face with that old guard. He ran terrified, his heart beating fast. "I have to get away!" He thought as he ran. There was no place to go, no place to hide! That's when an idea hit him.

"Of course!" He stopped right where he was and stood calmly waiting for the guard to catch up. He had a sly grin on his muzzle as the guard hurried towards him. Fenny suddenly held up his hand, and the guard stopped where he was, wondering why Fenny didn't run. As he stood staring at the guard, he pulled out a donut and held it up. "Come on... you want the donut? You know you want the donut...." The guard's eyes lit up and his mouth began to water. "Okay, fetch!" He said as he hurled it down the hall and out of sight. Forgetting all about Fenny the guard turned and ran after the pastry. "Works every time." Fenny grinned proudly, but didn't waste any time as he hurried in the other direction.

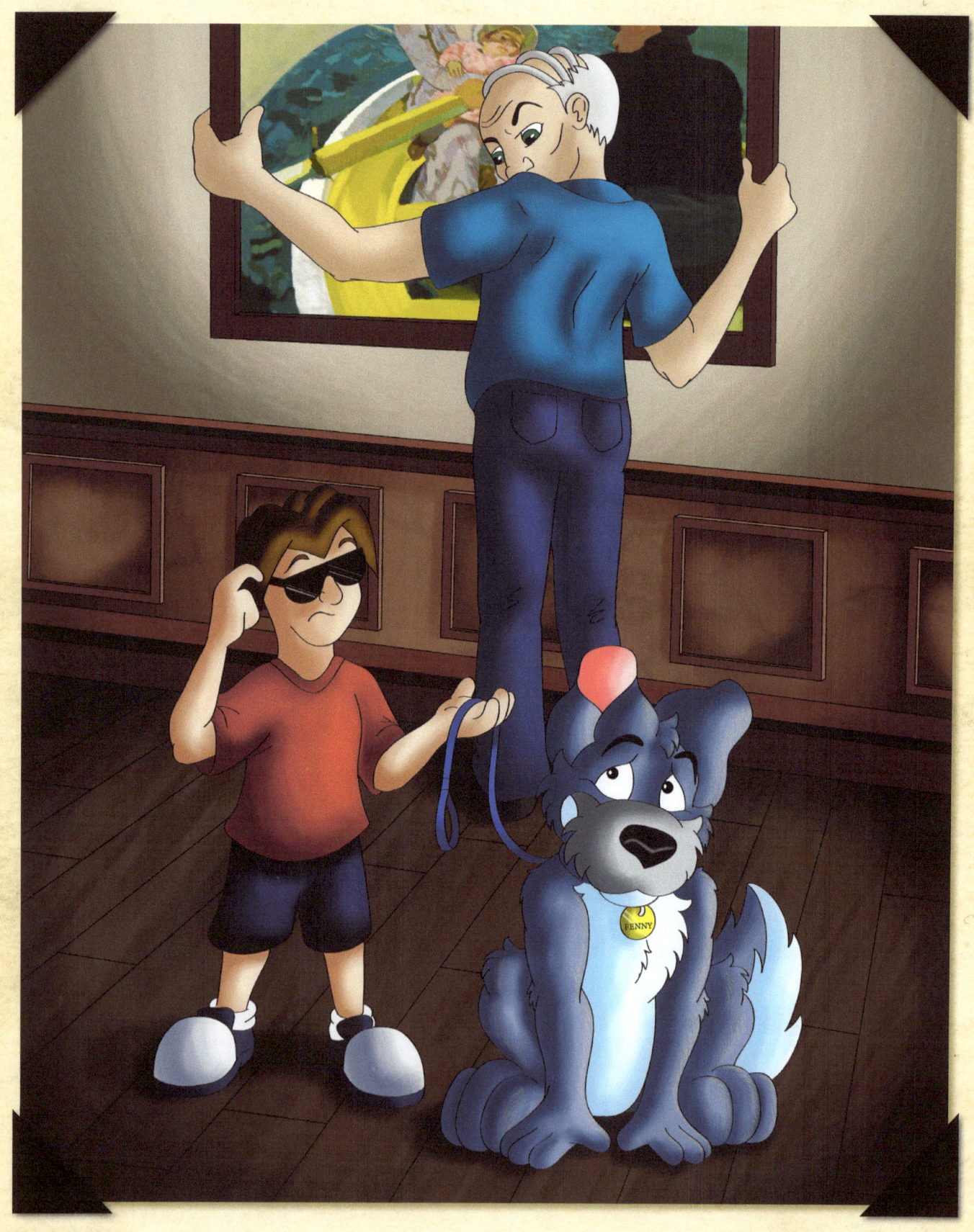

CHAPTER 10

He could finally hear someone in the next room. Fenny's tail wagged happily. "I know who that is!" He exclaimed, hurrying in. He barked in excitement as he finally found the nice lady that was giving the tour. She was just about to call the attention of everyone in the group, when she noticed Fenny hurrying towards her.

"Well, and here I thought I lost you. Wherever have you been?" She asked.

"You wouldn't believe me if I told you." He smiled, happy to have finally found a friendly face.

"Well, you're just in time, we're about to begin." She said as she called everyone's attention, to the figure of the artist. Fenny glanced around the room. "Mary Cassatt, worked in a style similar to Japanese prints, if you notice her work is very flat, kind of like a coloring book, there's no shading but has a great deal of patterns. She's most famous for her prints which were created later in her career, but in her earlier years exhibited with the impressionists, such as our next artist." The tour guide explained as she led the group into the next room.

Fenny followed the crowd, but as he did, he saw the guard approaching. He hadn't seen Fenny yet. "I have to hide." He thought as another idea popped in his head. He pulled a leash out of his backpack and put it on, handing the other end to a nearby child. Then he gave him a pair of sunglasses, and sat oh so still. "He can't kick out a seeing eye dog." He grinned to himself. As the guard passed by, straightening out a painting on the way, the seeing eye wolf went unnoticed.

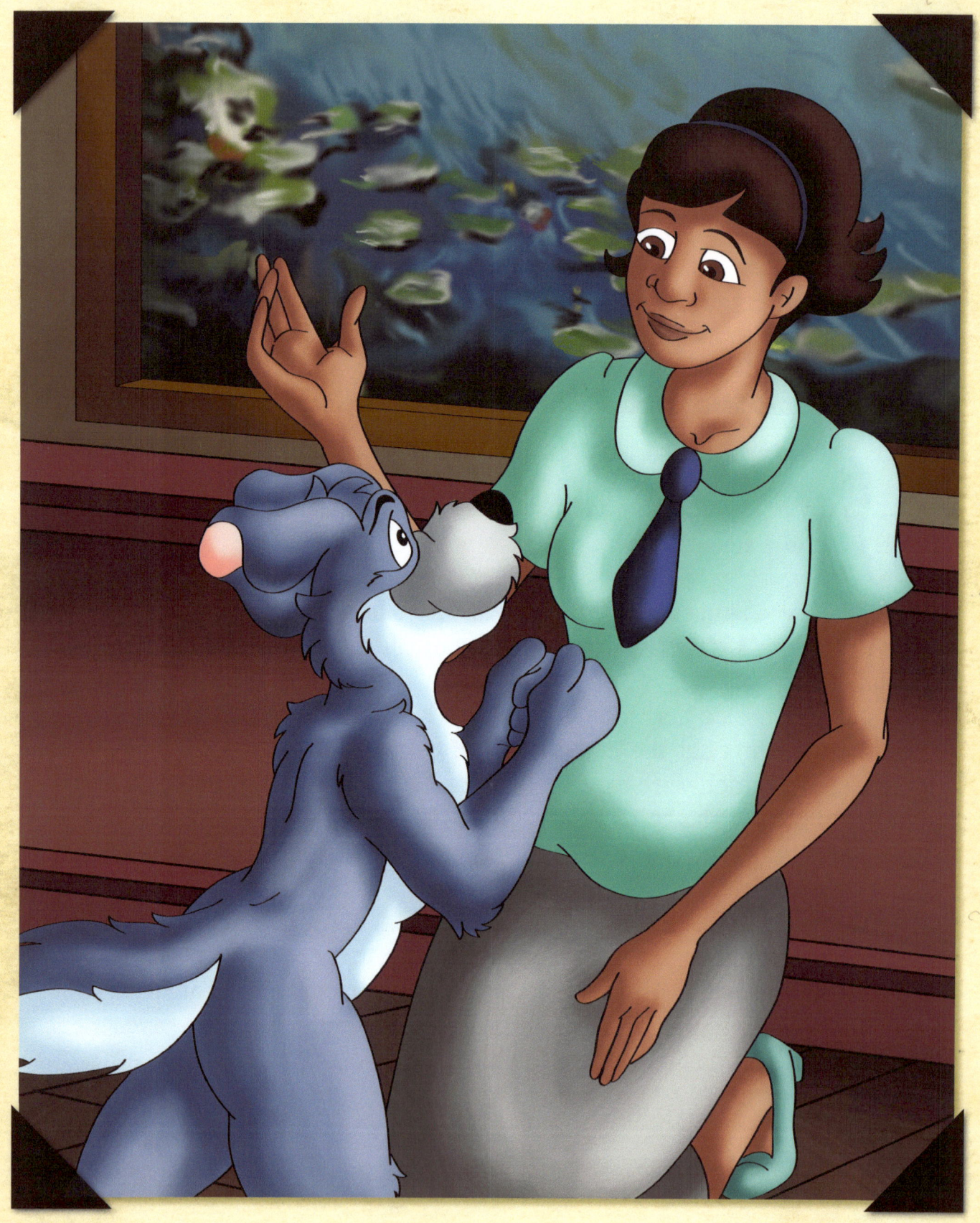

A WOLF'S GUIDE TO ART HISTORY

CHAPTER 11

A room of water lilies was next on Fenny's journey. He looked around, each painting seemed the same, but different. "What is this all about?" Fenny wondered as he approached the artist's display.

"Claude Monet was an impressionist, a term coined when a critic saw Monet's *Impression Sunrise*, back in 1872." The tour guide began to explain. "Monet painted a lot of water lilies as you can see, sometimes he would do several paintings of the same one, at different times of the day." She looked at Fenny, and at some of the younger children in the crowd. "Now, for all of you younger artists, you're going to find that persistence is a big part of being an artist, in fact Monet's painting *Women in the Garden* was rejected from the Salon of 1867, and even when he did finally get his painting into the gallery a couple years later, people laughed at it, calling it flat." She explained. "But, as you can see, persistence paid off for him." She said, motioning to the paintings now hanging in the big museum.

"So, even if my painting doesn't win, it just means I have to keep trying." Fenny thought to himself as he looked around at the beautiful works hanging on the walls. Fenny noticed another gold plaque like the one that had been in the room for Rockwell's paintings. "Paint it just as it looks to you, the exact color and shape, until it gives your own naïve impression of the scene before you." He read aloud. The tour guide looked at Fenny.

"That's right. That was the basis for an impressionist." She said. "If everyone would please follow me?" The lady said as she started to lead the group into the next room.

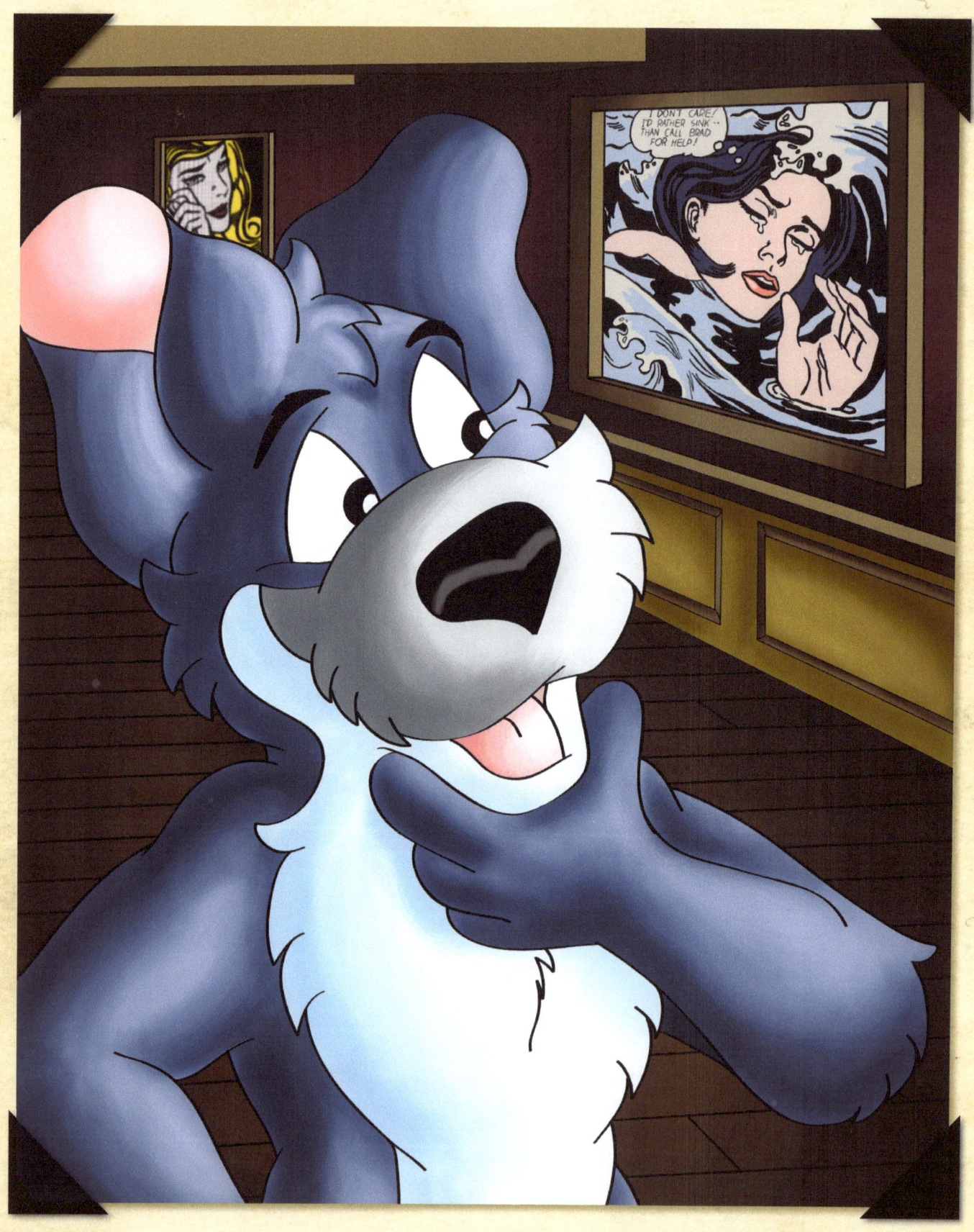

A WOLF'S GUIDE TO ART HISTORY

CHAPTER 12

Fenny did a double take as he looked around the room in disbelief. As he walked into the next room he looked upon huge panels of comic strips. He felt like he had stepped into a Sunday newspaper. Fenny quirked his brow in confusion, not quite sure how this was art.

"Roy Lichtenstein was a pop artist who focused a lot on pictures from popular culture sources. He started out as an abstract expressionist but slowly turned his attention towards imagery like commercial advertising, romance and war comics and cartooning in general." This artist had brought Fenny into a whole new world of art that he wasn't familiar with. It was a lot different than what he was use to, but it caught his interest.

"Hm... New ideas... New ways of thinking..." He thought to himself. "That's cool!" He chimed before heading out with his imagination working overtime. He had seen so many new things so far, he couldn't wait to be an artist too.

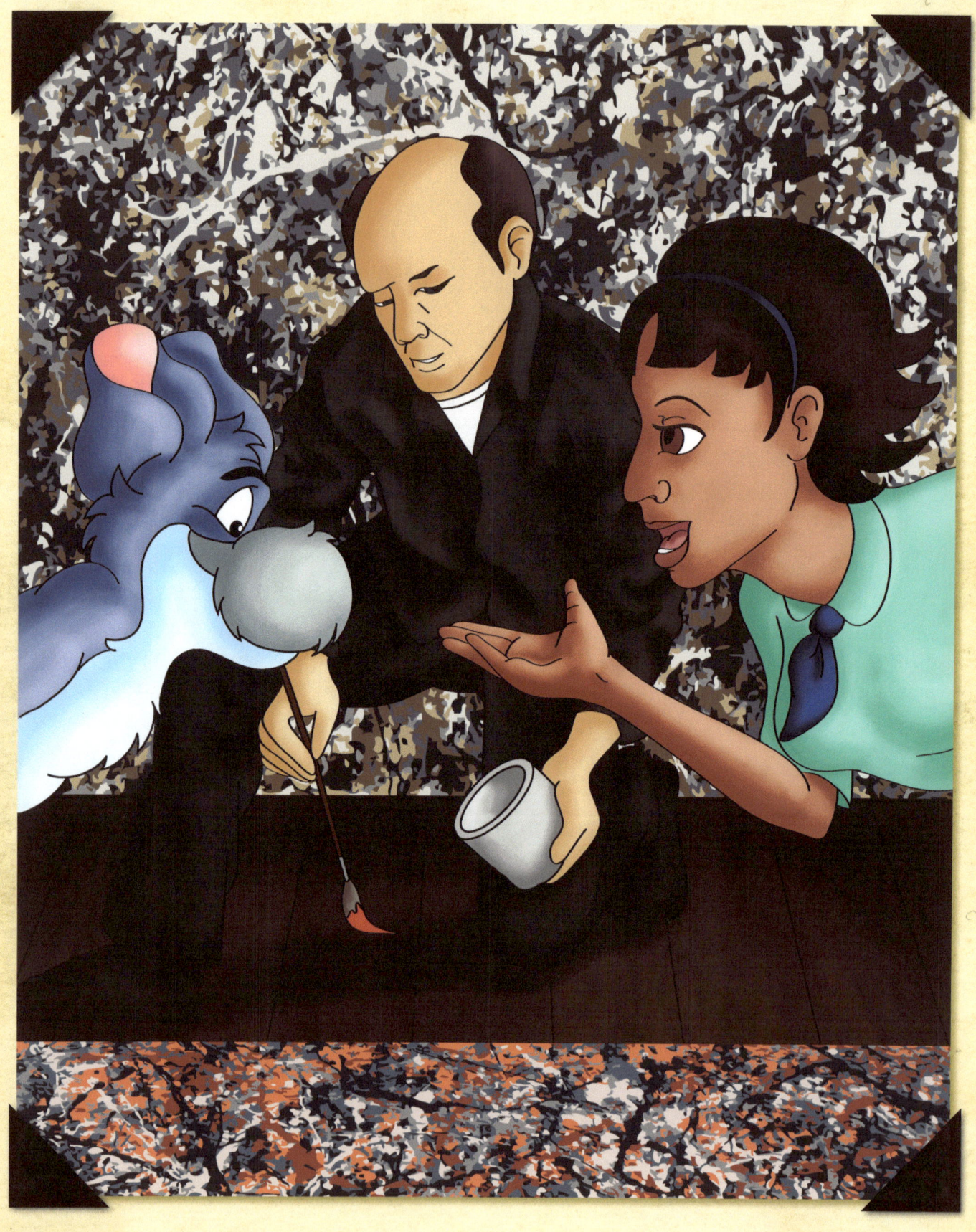

CHAPTER 13

The next room he walked into had paintings that were even wilder still. "Looks like the rags my mom makes me put under my paintings so I don't get paint on the floor." He thought to himself. There were big canvases covered with drops and splatters of paint. Fenny wasn't quite sure what to make of it. He thought about all of the other works he had seen, and tried to figure out what the artist was trying to tell him this time. Fenny followed the crowd towards the wax figure shown dripping paint onto a huge canvas on the floor.

"Here, is Jackson Pollock, a very influential American artist and a huge force in the abstract expressionist movement. He perfected a technique where he would drip paint onto the canvas." The tour guide told everyone.

"Looks like fun!" Fenny thought.

"He would use his entire body to paint with rather than just his arms. Time magazine even dubbed him as Jack the Dripper, because of his painting style." Fenny raised his hand, bubbling over with curiosity.

"What is he trying to show though? All of the other artists have been doing pictures of something." Fenny said not quite understanding.

"Actually, pup, a lot of people have asked that. To quote Mr. Pollock ..look passively and try to receive what the painting has to offer and not bring a subject matter or preconceived idea of what they are to be looking for." Fenny cocked his head.

"Huh?" Fenny seemed more confused than ever. The tour guide snickered a little at the expression on his face.

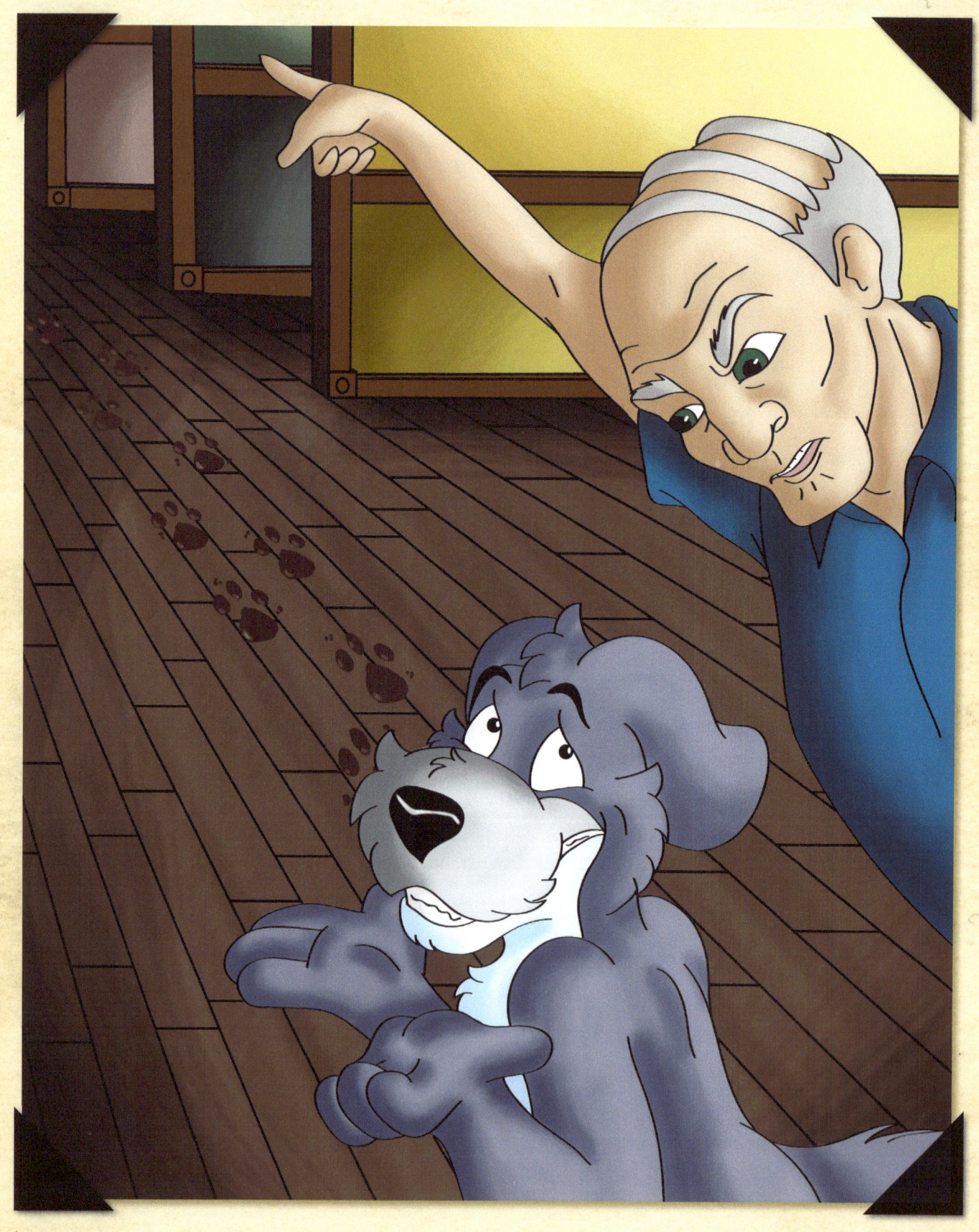

A WOLF'S GUIDE TO ART HISTORY

"In other words try looking at the painting for what it is, rather than trying to find something in it." She explained. Fenny looked at the paintings on the walls.

"So, just enjoy the colors and the painting, just for being a painting?" Fenny asked.

"Pretty much." The tour guide nodded. "Actually, you're having a very similar reaction to what a lot of people had when Jackson Pollock was just starting to come out as an artist. Give it some time, I think you'll catch on." She assured Fenny, before starting into the next room. Fenny stayed behind a moment, gazing at the paintings on the wall.

"Wow, I have a lot to learn, still." Fenny thought to himself as he stood looking up at the enormous painting in front of him. Just as he was ready to turn to leave he heard a voice hiss.

"Now, you're coming with me!" That guard growled.

"How did you find me?" Fenny gasped.

"I could track you in the dark with those muddy paw prints."

"It's expressionist art!" Fenny said defensively.

"Expressionist? You'll catch an express train out of here, if you know what's good for you." The guard yelled, shaking his fist. Fenny ran into the next room. There were big wooden crates and a sign letting guests know this exhibit was under construction. Fenny didn't hesitate and jumped into one of the big wooden boxes, hiding out of sight.

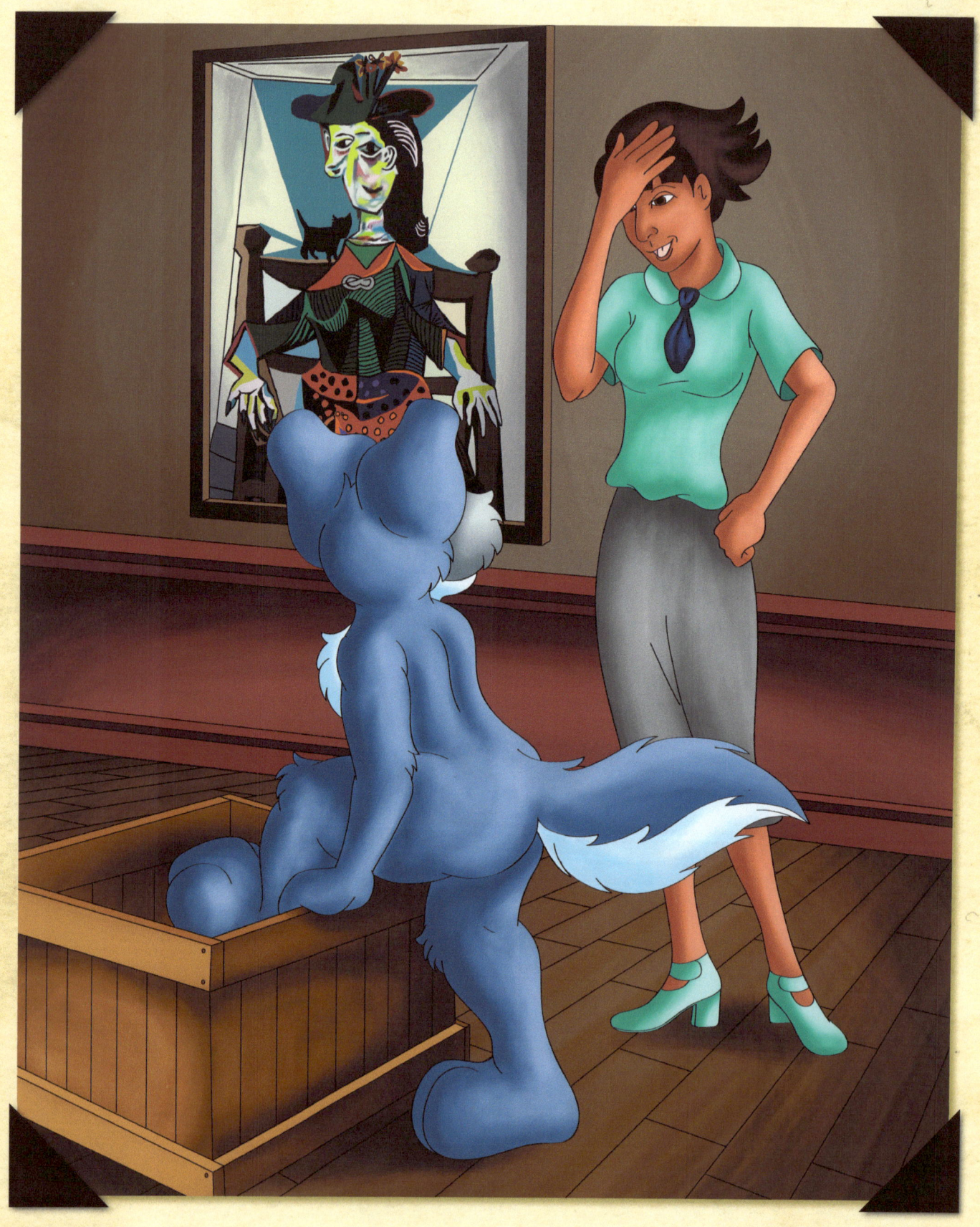

CHAPTER 14

Fenny heard footsteps heading closer, and as the lid opened he gasped looking up.

"What are you doing?" The tour guide asked curiously.

"Uh.... Cubism?" He grinned sheepishly as the tour guide helped him out. The tour guide snickered a little.

"I'm sorry kiddo, but that's not cubism. It's about more than just boxes and squares, here I'll show you." She said, leading Fenny to another hall.

"See, these were done by Pablo Picasso." She showed Fenny a few very colorful paintings. "Picasso would paint a face so that you could see a couple different angles all at once." She explained. "Now, that's cubism."

"Oh, sure, I knew that." Fenny said before following her into the last hall on their tour, where they met up with the rest of the group.

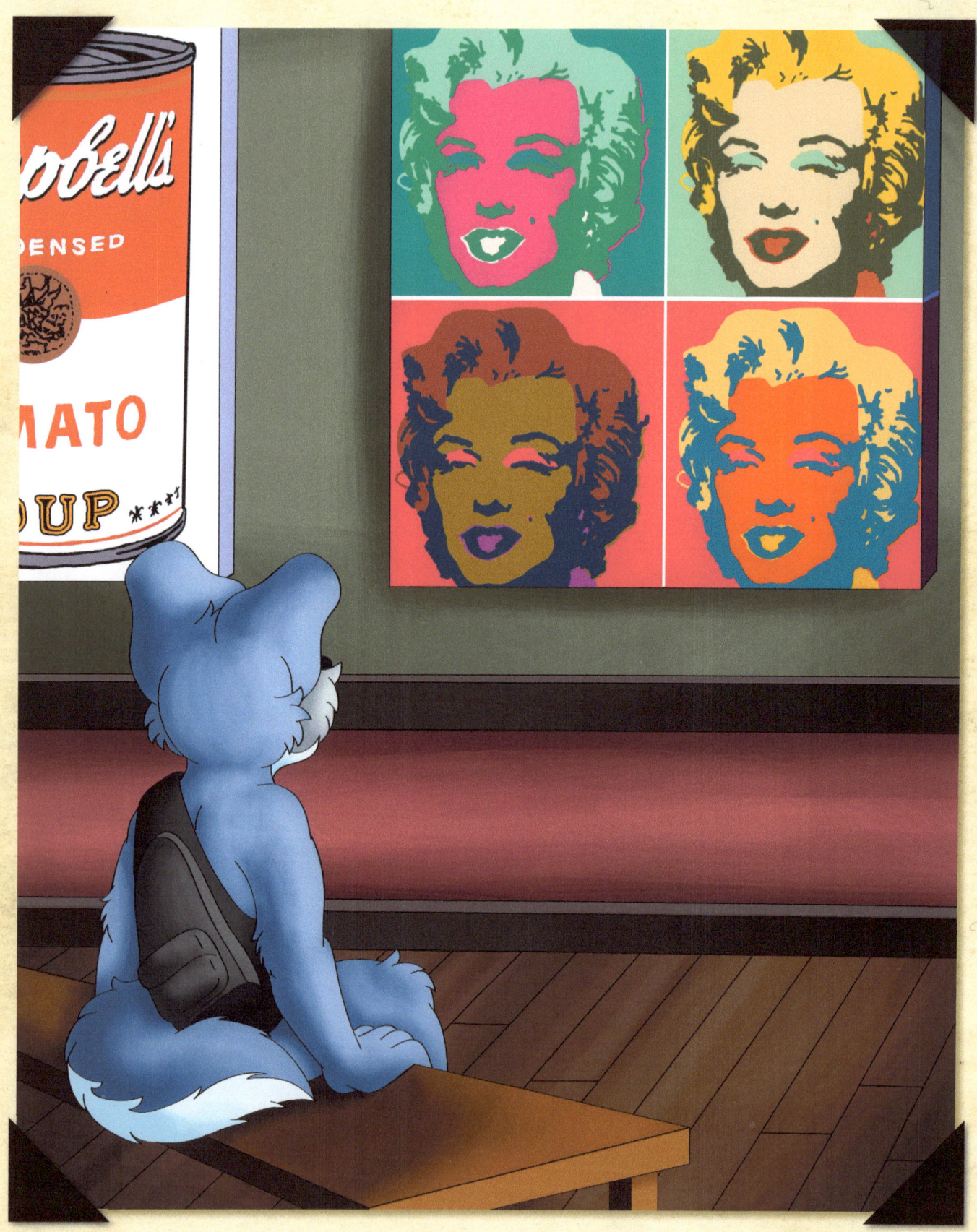

A WOLF'S GUIDE TO ART HISTORY

CHAPTER 15

"All right everyone, as you all know, today we have a special event going on downstairs. This will be our last stop on the tour before heading down." She lead the group into a big room. Fenny's ears perked up curiously and he cocked his head a little.

"Weird..." He muttered to himself as he looked at some of the art on display. There were pictures of cans of soup, and pictures of a lady, and so many more strange things to see.

"Andrew Warhola, better known as Andy Warhol was a pop artist much like Lichtenstein, who we saw earlier." The guide began. "He showed an early interest in art, and soon started working in magazine illustration and advertising." She explained. "However, it was in the 1960's when he began to make paintings of famous American products, like the soup can he's so well known for." She motioned to the painting on display. "He started silk screening, so not only was he making art out of things that were mass produced, but he was also mass producing art. In doing so he sparked a revolution in the art world. His work became very popular but also very controversial. Much of Warhol's work around this time was focused around pop culture items, like soda brands, celebrities, and images out of newspaper headlines."

A WOLF'S GUIDE TO ART HISTORY

She led the group back towards the hall, "This leads us to our special event today. In the tradition that art is ever changing, evolving, and being passed on, we are judging a contest today to see who's piece will be displayed here in the museum, and win the special grand prize." She explained as she began to guide them down through the next hall. As Fenny followed them down, he glanced back at the strange new art, and thought about all of the great works of art he had seen so far.

"I wonder what kind of new art I'll get to see as I grow up." He thought. They stepped out to a balcony and a set of stairs that led to a big room that was filled with the entries of all sorts of artists. Fenny's jaw dropped and his heart sank a little as he looked at all of the paintings, sculptures, and creations that his little painting was competing with. It seemed so overwhelming.

Just as he was about to turn to leave he remembered something he had learned earlier that day. He remembered how the other artists had struggled to become so wonderful. He thought about the beautiful paintings that he had seen of Monet's, and remembered how he had been turned away but kept working at what he did. He found so many new kinds of art, and before he knew it, it was time to announce the grand prize winner.

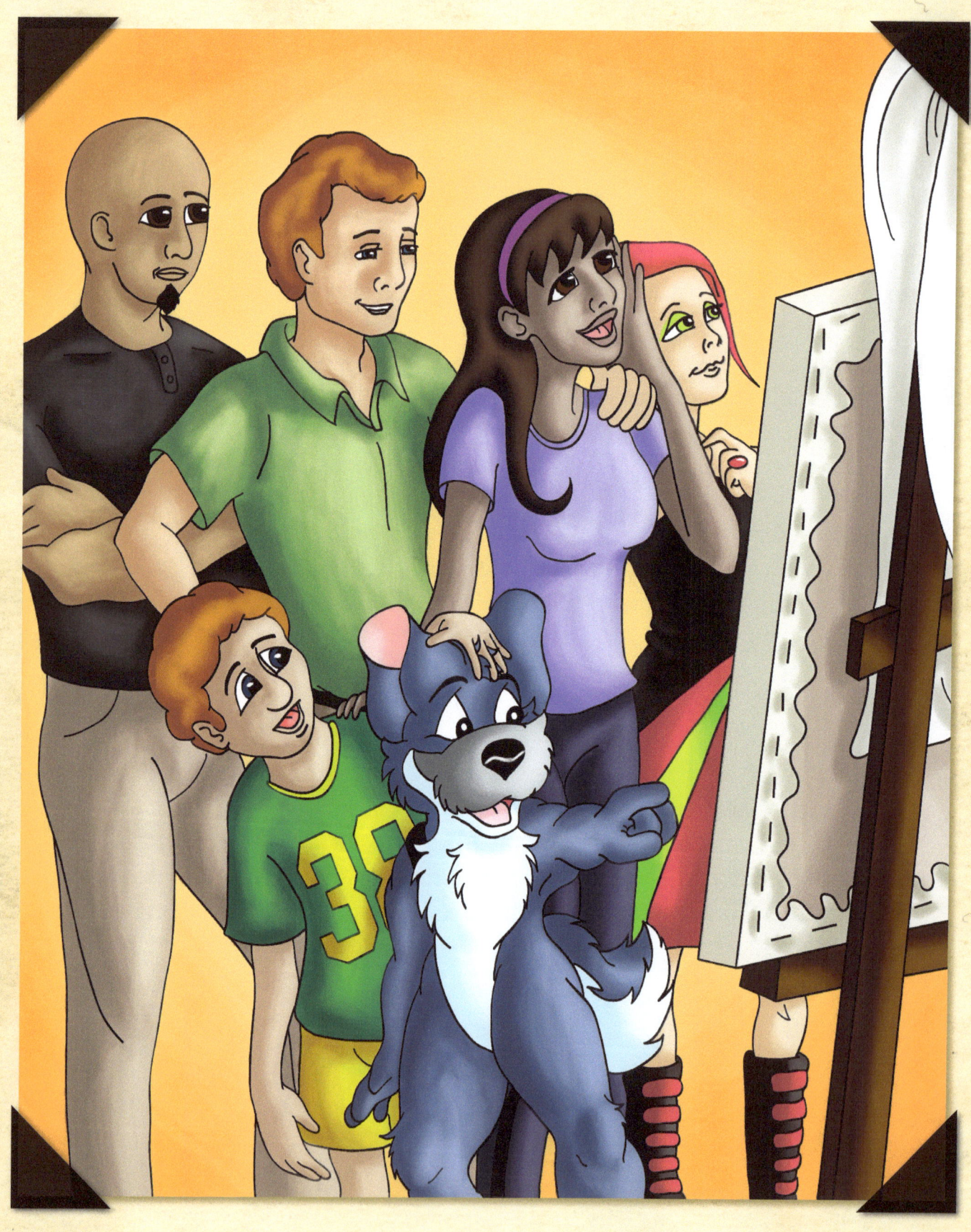

A WOLF'S GUIDE TO ART HISTORY

CHAPTER 16

A man stepped up on a big platform and spoke into the microphone. "Welcome ladies and gentlemen, we have arrived at the moment I'm sure so many of you have been waiting for." The man announced. "Art today has grown to be a very diverse and complicated thing, as you can see. The judges had a very difficult time deciding on the winner. They looked at not only the traditional aspects of the pieces: composition, form, shape, etcetera." Fenny's attention was broken as he heard an excited whisper.

"Hey, Fenny!" He turned his head to find his big brother and his mom and dad. His ears perked up and his tail wagged happily.

"You came!" He exclaimed excitedly.

"Of course, we wouldn't miss this for the world." His mom said.

"Hey, where's your painting? I can't find it anywhere." Jay asked.

"And, without further delay, I present to you, our grand prize winner." They heard the man on the stage announce as they drew a white sheet off of the covered art piece.

"Oh, there it is." Fenny smiled as he pointed to his painting. Realization suddenly hit him. "I won!" He exclaimed with a yelp. He couldn't believe his eyes. Of all the wonderful works of art that had been entered, it was his little painting that the museum chose.

"Way to go, Fenny!" Jay told, ruffling the fur on his head. "I knew you could do it."

"Can we please have the artist come on stage and be recognized?" He asked. Fenny hurried up to the stage and stood next to the man. It took a moment for the man to realize why the wolf pup was there.

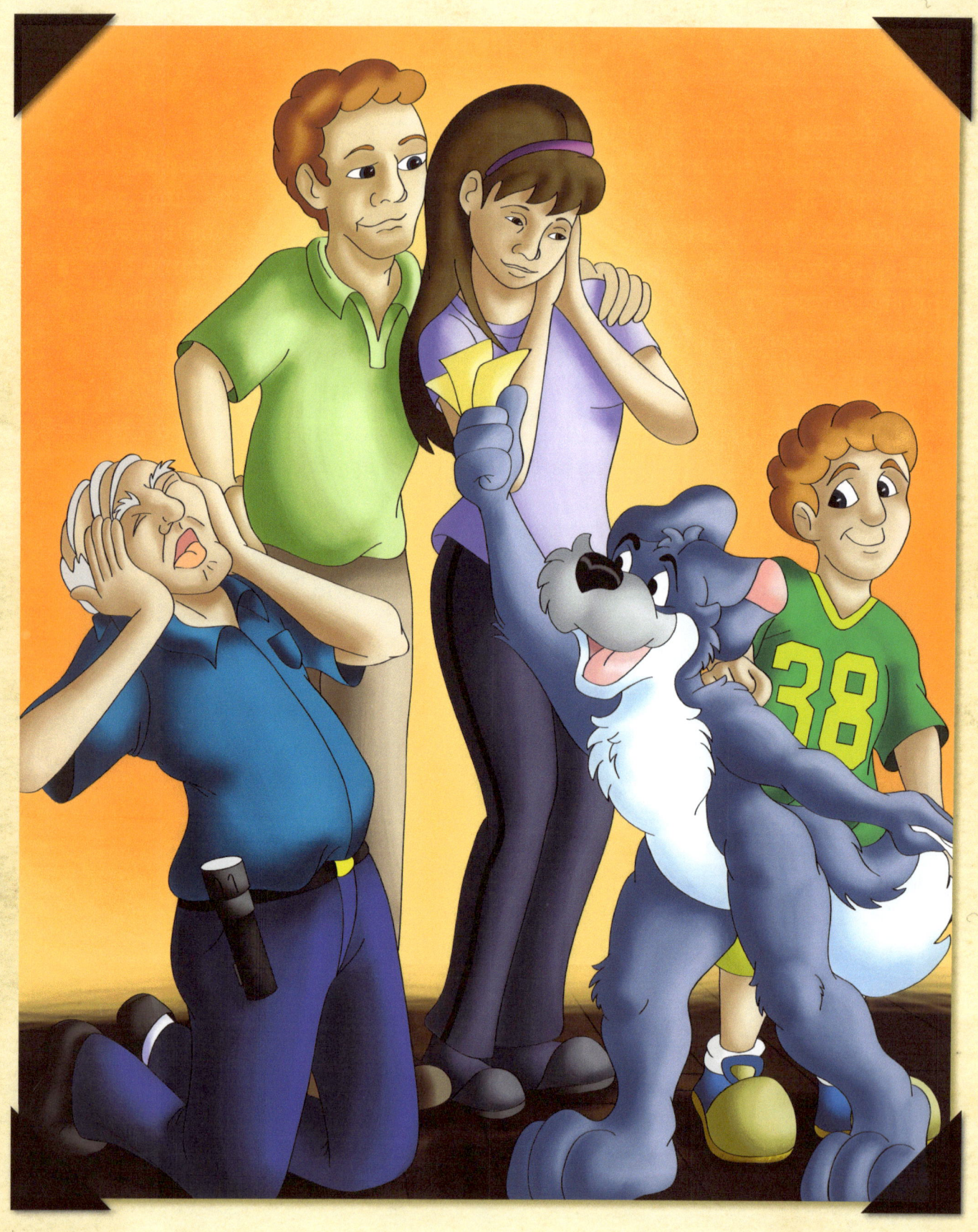

A WOLF'S GUIDE TO ART HISTORY

"Wait, you're... the artist?" He quirked a brow. Fenny gave an excited nod.

"No, that can't be!" Fenny suddenly heard a voice yell as the guard approached from in the crowd. "He's not even supposed to be in here! He's not even human." Fenny cocked his head in a puzzled look, not understanding that he wasn't like them. The tour guide suddenly stepped in.

"Nothing in the rules say anything about that. In fact, the entry said that it was open to everyone." She said.

"This is an outrage." The guard protested angrily.

"Most art is!" Another voice suddenly broke in, silencing the crowd and the guard. A man in a suit with a badge that read curator stepped onto the stage. "This contest is to judge the art not the artist. This pup... this artist... gave us a new perspective, and a refreshing view of the world around us, regardless of who he is."

"You can't just let anyone into my museum." The guard snapped. The curator raised an eyebrow.

"Your museum? The last time I checked this wasn't your museum, and your job was to keep the art in, not the people out!" He glared at the guard. The curator then turned to Fenny and the gathered crowd. "The world of art is always changing, and you never know what you may see. Tomorrow's treasures lie in us, and come from artists, like you and me. It's for this reason, we thought this prize would be appropriate." The curator smiled kindly as he handed Fenny an envelope. The room went silent with curiosity as they watched Fenny's eyes light up and his tail wag happily.

"Lifetime passes for me and my family!" He exclaimed as he pulled them out of the envelope. "Thank you, this is the best prize ever!"

"Worst prize ever...." The guard groaned as he sank defeated.

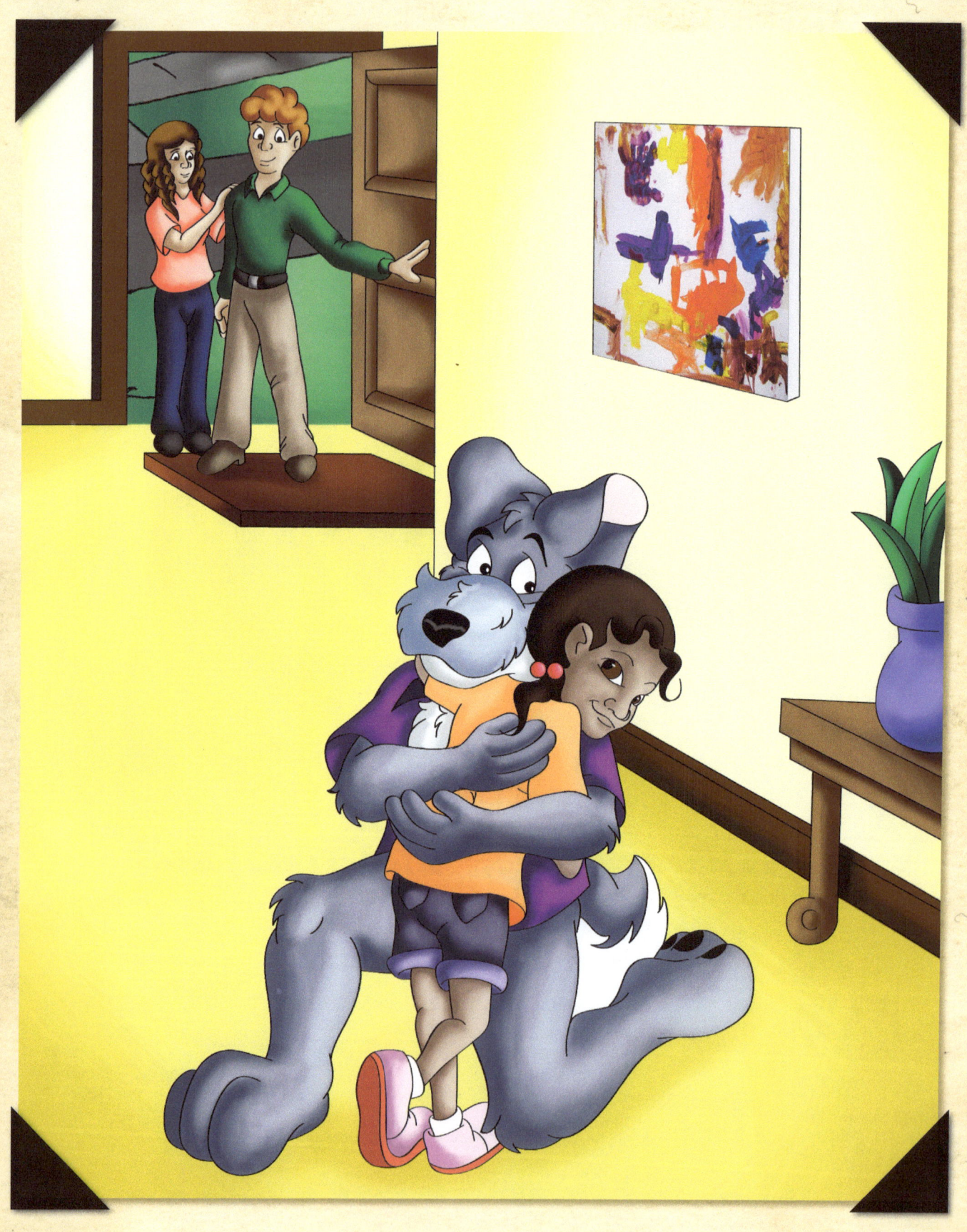

CHAPTER 17

Fenny chuckled to himself. "And, you know, until the day that old guard retired, he always gave me the meanest look." Fenny couldn't help but laugh as he remembered. "It was worth it though. What I learned from those artists helped me to grow as an artist myself, and encouraged me to try new things."

"Does this mean I can have my painting hung in the museum too, uncle Fenny?" Kat asked, holding up her picture.

"Maybe someday." Fenny said as he took the painting and led her into the living room. "If you practice, and never stop trying to learn." He smiled to her. "But, until then." He took down one of his own paintings on the wall, and hung Kat's up in its place. "Your art will always have a loving home on my walls." Fenny said as he gave her a big hug.

References

Da Vinci, Leonardo. <u>Cecilia Gallerani (Lady with an Ermine)</u>. [c. 1483-1485]. Czartoryski Museum, Cracow. <u>Italian Renaissance Art</u>. By Laurie Schneider Adams. Colorado: Westview Press. 2001. 304

Da Vinci, Leonardo. <u>Last Supper</u>. [c. 1495-98]. Monastery of Santa Maria delle Grazie, Milan. <u>Art: A Brief History</u>. By Marilyn Stokstad. New York: Harry N. Abrams, Inc. 2000. 279

Da Vinci, Leonardo. <u>Mona Lisa</u>. [c. 1503-6]. Musée du Louvre, Paris. <u>Art: A Brief History</u>. By Marilyn Stokstad. New York: Harry N. Abrams, Inc. 2000. 280

Da Vinci, Leonardo. "Self Portrait" Drawing. Wikipedia.org. 16 Apr. 2012 <http://en.wikipedia.org/wiki/File:Leonardo_da_Vinci_-_Self-Portrait_-_WGA12798.jpg>.

Da Vinci, Leonardo. "Portrait of a Young Man ('The Musician')" Painting. Wikipedia.org. 16 Apr. 2012 <http://en.wikipedia.org/wiki/File:Leonardo_da_Vinci_-_Franchino_Gaffurio.jpg>.

Da Vinci, Leonardo. "Virgin of the Rocks" Painting. Wikipedia.org. 16 Apr. 2012 <http://en.wikipedia.org/wiki/File:Leonardo_da_Vinci_-_Virgen_de_las_Rocas_%28Museo_del_Louvre,_c._1480%29.jpg>.

Degas, Edgar. <u>Little Dancer Fourteen Years Old</u>. [1881]. Collection Mr. and Mrs. Nathan Smooke, Los Angeles. <u>19th Century Art</u>. By Robert Rosenblum and H.W. Janson. New York: Harry N. Abrams, Inc. 1984. 473

Duchamp, Marcel. "Nude Descending a Staircase, No. 2" Painting. Wikipedia.org. 16 Apr. 2012 <http://en.wikipedia.org/wiki/File:Duchamp_-_Nude_Descending_a_Staircase.jpg>.

Lichtenstein, Roy. "Crying Girl" Painting. lichtensteinfoundation.org. 16 Apr. 2012 <http://www.lichtensteinfoundation.org/3352.htm>.

Lichtenstein, Roy. "Drowning Girl" Painting. Wikipedia.org. 16 Apr. 2012 <http://en.wikipedia.org/wiki/Roy_Lichtenstein>.

Michelangelo. <u>The David</u>. [c. 1500]. Saint Peter's, Vatican, Rome. <u>Art: A Brief History</u>. By Marilyn Stokstad. New York: Harry N. Abrams, Inc. 2000. 283

Michelangelo. <u>The Pietà</u>. [c. 1500]. Saint Peter's, Vatican, Rome. <u>Art: A Brief History</u>. By Marilyn Stokstad. New York: Harry N. Abrams, Inc. 2000. 283

Michelangelo. <u>Sistine Ceiling</u>. [c. 1508-12]. Sistine Chapel, Rome. <u>Art: A Brief History</u>. By Marilyn Stokstad. New York: Harry N. Abrams, Inc. 2000. 285

Monet, Claude. <u>Water Lilies</u>. [c. 1920]. The Museum of Modern Art, New York. <u>Art: A Brief History</u>. By Marilyn Stokstad. New York: Harry N. Abrams, Inc. 2000. 411

Munch, Edvard. The Scream. [1893]. Nasjonalgalleriet, Oslo. Art: A Brief History. By Marilyn Stokstad. New York: Harry N. Abrams, Inc. 2000. 421

Nike (Victory) of Samothrace. [c. 190 BCE (?)] Musée du Louvre, Paris. Art: A Brief History. By Marilyn Stokstad. New York: Harry N. Abrams, Inc. 2000. 116

Picasso, Pablo. "Dora Maar Au Chat" Painting. Wikipedia.org. 16 Apr. 2012 <http://en.wikipedia.org/wiki/File: Dora_Maar_Au_Chat.jpg>.

Rockwell, Norman. "Four Freedoms" Illustration. Wikipedia.org. 16 Apr. 2012 <http://en.wikipedia.org/wiki/ Four_Freedoms_%28Norman_Rockwell%29>.

Rockwell, Norman. "The Problem We All Live With" Illustration. Wikipedia.org. 16 Apr. 2012 <http:// en.wikipedia.org/wiki/File:The-problem-we-all-live-with-norman-rockwell.jpg>.

Rockwell, Norman. "Rosie The Riveter" Illustration. Wikipedia.org. 16 Apr. 2012 <http://en.wikipedia.org/wiki/ File:RosieTheRiveter.jpg>.

Seurat, Georges. Sunday Afternoon on the Island of La Grande Jatte. [1884-86]. The Art Institute of Chicago, Illinois. Art: A Brief History. By Marilyn Stokstad. New York: Harry N. Abrams, Inc. 2000. 414

Van Eyck, Jan. Portrait of Giovanni Arnolfini (?) and His Wife, Giovanna Cenami (?). [1434] The National Gallery, London. Art: A Brief History. By Marilyn Stokstad. New York: Harry N. Abrams, Inc. 2000. 257

Van Gogh, Vincent. The Starry Night. [1889]. The Museum of Modern Art, New York. Art: A Brief History. By Marilyn Stokstad. New York: Harry N. Abrams, Inc. 2000. 418

Van Rijn, Rembrandt. "Belshazzar's Feast" Painting. Wikipedia.org. 16 Apr. 2012 <http://en.wikipedia.org/wiki/ Belshazzar%27s_Feast_%28Rembrandt%29>.

Van Rijn, Rembrandt. "Self Portrait" (1658) Painting. Wikipedia.org. 16 Apr. 2012 <http://en.wikipedia.org/wiki/ File:Rembrandt_Harmensz._van_Rijn_130.jpg>.

Warhol, Andy. "Marilyn Monroe" Screen Print. students.sbc.edu. 16 Apr. 2012 <http://www.students.sbc.edu/ kitchin04/artandexpression/contemporary%20art.html>.

Warhol, Andy. Soup Can. [1961-2]. Private Collection. The 20th Century Artbook. New York: Phaidon Press. 2001. 484

www.ingramcontent.com/pod-product-compliance
Lightning Source LLC
Chambersburg PA
CBHW051025180526
45172CB00002B/471